STAN DOUGLAS **EVERY BUILDING ON 100 WEST HASTINGS**

Stan Douglas, *Every Building on 100 West Hastings* (2001), C-print (66 cm x 426.9 cm)
Courtesy of the artist and David Zwirner, New York

STAN DOUGLAS

EVERY BUILDING ON
100 WEST HASTINGS

edited by Reid Shier

Contemporary Art Gallery / Arsenal Pulp Press
Vancouver

CONTEMPORARY ART GALLERY
555 Nelson Street
Vancouver, B.C.
Canada v6b 6r5
contemporaryartgallery.ca

ARSENAL PULP PRESS
341 Water Street, Suite 200
Vancouver, B.C.
Canada v6b 1b8
arsenalpulp.com

Arsenal Pulp Press gratefully acknowledges the support of the Canada Council for the Arts and the British
Columbia Arts Council for its publishing program, and the Government of Canada through the Book Publishing
Industry Development Program for its publishing activities.

The Contemporary Art Gallery is generously supported by the Canada Council for the Arts, the City of Vancouver,
the Province of British Columbia through the BC Arts Council, and the BC Gaming Commission.

The Canada Council | Le Conseil des Arts
for the Arts | du Canada

City of Vancouver

BRITISH
COLUMBIA
ARTS COUNCIL
Supported by the Province of British Columbia

Design: Solo
Cover photography: Stan Douglas
Printed and bound in Canada

NATIONAL LIBRARY OF CANADA CATALOGUING IN PUBLICATION DATA:

Douglas, Stan
 Stan Douglas

 Copublished by Contemporary Art Gallery.
 ISBN 1-55152-135-0

 1. Douglas, Stan. Every building on one hundred west hastings. 2. Photography, Artistic. 3. Downtown Eastside
(Vancouver, B.C.) – Pictorial works. 4. Downtown Eastside (Vancouver, B.C.) I. Shier, Reid, 1963- II. Contemporary
Art Gallery (Vancouver, B.C.) III. Title. IV. Title: Every building on one hundred West Hastings.

N6549.D68A63 2002 779'.997113304'092 C2002-911017-3

CONTENTS

FOREWORD AND ACKNOWLEDGMENTS

It rarely happens that an exhibiting institution such as the Contemporary Art Gallery will focus all of its energy and resources on the critical exploration and elaboration of a single emblematic work of art. But such is the depth and poignancy of Stan Douglas' *Every Building on 100 West Hastings* that the effort seems necessary in relation to the artist's remarkable accomplishment. From this single monumental photograph the authors of the present volume have excavated layers of intersecting narrative where local histories meet global politics, and where social tragedy is enacted in the psychic charge of the image.

The publication accompanies the exhibition of Douglas' film/video installation, *Journey into Fear*, along with the suite of related photographs of which *Every Building on 100 West Hastings* is one. Like earlier works of his, *Journey into Fear* abandons linear narrative in order that the viewer must engage in a struggle for meaning. With the aid of a computer program that randomly pairs sound and image through 625 possible permutations, the drama of the film's protagonists is continuously shifting, much like the relations of global finance that the work takes for its subject. Such irresolution and ambiguity is in sharp contrast to the abject failure of urban planning schemes that *Every Building on 100 West Hastings* seems to witness. And yet, there is also a future to this site, a future whose stresses and permutations are yet to be worked out. While remaining ambiguous and transitory, that future drama is urgently informed by this singular image.

Stan Douglas is one of Vancouver's most acclaimed artists, recognized internationally as a leading practitioner in the field of film and video. It is a particular pleasure to present this exhibition in his home town, where his

work is far too rarely seen. We are grateful for his enthusiastic participation in this project, and for his invaluable assistance with its realization.

We would also like to thank each of the authors, Denise Blake Oleksijczuk, Jeff Derksen, Neil Smith, Jeff Sommers, and Nick Blomley. This publication has benefitted enormously from their thoughtful contributions.

The collaboration between the Contemporary Art Gallery and Arsenal Pulp Press is one we hope will be the first of many, and we thank the enthusiastic support Brian Lam, Robert Ballantyne, and Blaine Kyllo have brought to every aspect of this publication's production.

This is the first time that McCarthy Tétrault LLP has sponsored a publication with the Contemporary Art Gallery. Their immediate and enthusiastic response to our invitation is gratifying evidence of their committed support for contemporary art. I am particularly indebted to Thomas H. Bjarnason for his involvement with this project.

Christina Ritchie
Director, Contemporary Art Gallery

INTRODUCTION

S tan Douglas' portrait of the south side of Vancouver's 100 block West Hastings Street shows a row of buildings in evident disrepair. Many of them are boarded up and appear on the verge of demolition. Paradoxically, there's a stark contrast between the buildings in Douglas' panoramic image and ones directly around the corner and down the street. Save for an area to its east, the architecture of the 100 block stands yards from buildings that are, economically and socially, worlds apart. Three blocks west the heart of the downtown core begins, and with it the start of the most expensive commercial real estate in Vancouver. Two blocks north along Water Street in Gastown, buildings in every way similar to the dilapidated Edwardian structures of Hastings are renovated into loft apartments and tourist shops. To the south along False Creek, sparkling condominium towers rise in one of the most comprehensively planned inner city redevelopment schemes in North America. Within this enfolding sphere of civic entitlement and reimagination, the 100 block stands out in stunning relief.

This conjunction of ruin and renovation isn't an oddity brought on by the vagaries of Vancouver's redevelopment. The 100 block of West Hastings looks the way it does for other reasons. The essays that follow illustrate the social space of this block, and describe the border that often differentiates Hastings Street, and its residents and habitués, from the rest of Vancouver. This division is artificial. It's a shifting border that waxes and wanes across a number of social boundaries and with changing needs. As Jeff Sommers and Nick Blomley point out, an elusive demarcation which presumes a gateway to this part of Vancouver has been described as an entry into "hell itself." This hyperbole can be found in the language of many cities and isn't

exclusive to Vancouver. It forms part of a contract of permission and, as Neil Smith and Jeff Derksen suggest, is deployed as a means of defining a class perimeter from which those outside strategize resettlement within. Borders are tools that differentiate those included from those who are not, and are utilized, as Denise Oleksijczuk concludes, to sanction particular types of behaviour for those crossing the line.

In the late 1990s I ran a gallery on the 100 block of West Hastings. In hindsight, the intimacy I developed with the street may have clouded my view of it. The area was disintegrating, but it appeared to me as part of a general deterioration that had been in progress for some time, and which I had become used to. Local theories abound as to when this slide started. One supposition is that Hastings started going downhill in the 1950s when the interurban rail line running parallel to the street along Pender closed, and the theatres and shops that once made the street the epicentre of Vancouver moved uptown toward Granville and Robson Streets.

During the 1990s, however, the decline steepened, plummeting toward the decade's end. Not coincidentally, this was also when crack entered Vancouver's street drug culture. The number of drug dealers stationed on the sidewalk in front of the gallery ballooned as the months of 1997 wore on, testament, as far as I could understand, to the demand (and profitability) of rock cocaine. In contrast to the sometimes steep price of powder, rocks were (and are) sold for as little as five dollars each, and business in the late '90s boomed. Within the twenty-four hour street market, anyone trying to operate a business out of a 100 block storefront was offered two clear choices: cater to this sidewalk economy outright, or hope for some crest of the incoming tide. Those who tried legitimate routes didn't last. Pawn shops and twenty-four-hour convenience stores continue to thrive by fencing stolen goods or by operating as drug fronts themselves. Other ventures – like the restaurants and galleries which, even as late as 1999, rented space on the street – are gone.

Gone, too, are the artists who used to rent space in the lofts above these storefronts. A few remain, mixed in with the remaining tenants, but the level of artistic productivity this particular block of Vancouver once nurtured is a fraction of what it used to be. I can claim some small responsibility for this as one of those who contributed to the Or Gallery's decision to move to a more upscale neighbourhood. The decision was in response to the amplifying aggression that accompanied the drug trade. It was a debatable choice, and was justified in tandem with the departure of a number of cultural organizations from the area during 1999 and 2000.

This pattern of withdrawal from a city's problem area is a common narrative, and is allusive of the familiar exodus from urban cores that has plagued many North American cities in the post-war years. The retreat was of minor scope in Vancouver, but it raises the spectre of an interrelated tendency found as much in Vancouver as any city with a history of urban flight. The increase in real estate speculation anticipating the redevelopment of abandoned urban areas has become, in the past forty years, epidemic. In their analysis of recent trends in gentrification, Neil Smith and Jeff Derksen show how the rapid expansion of residential areas and service sectors in inner city cores has become an organized, meticulously planned global phenomenon.

But the migration upon which this speculation is based still must be considered against the changing economics of the post-war economy. In the United States, the racial motivations for the retreat of mostly white city dwellers into the suburbs was precipitated by the dereliction of the industrial base into which the fabric of inner cities was often deeply-knit. The gutting of the economies at the heart of cities like Detroit, for instance, was provoked by the ascendancy of transnational automakers first located in Japan. Detroit's inner city was left a ghost town when those that could leave, did. Business dried up, and rather than change or adapt, the people with the means simply abandoned the area in search of greener pastures.

In Vancouver, the history of the Downtown Eastside (DES) offers a small but poignant corollary. In their constructive history of Hastings Street, Jeff Sommers and Nick Blomley shed light on how the DES once served a transient community of (mostly) men employed in British Columbia's resource industries. As the lumber mills and salmon canneries moved progressively further from the city, however, this population was either forced to move with them, or remain behind in a deteriorating wake.

Hastings Street was for many years nicknamed Skid Road. This term derives from roads used to skid logs to a mill, and it probably originated in the turn of the century communities of Seattle and Vancouver. Then it was used to describe the community of bars and brothels that grew up around logging camps, and it wasn't until after the war that the term took on the pejorative meaning of its current, world-wide renown. Interestingly, as Sommers and Blomley suggest, one of the first derogatory applications of this West Coast epithet may have been to describe Hastings Street.

Ironically, it wasn't until the 1970s and '80s, after concerted community activism, that the area was renamed the Downtown Eastside, and for a time the area was looking up. Then in 1993, a date often flagged as the real beginning of the end for the 100 block and its environs, Woodward's department store closed its doors. Woodward's was far and away the area's largest business, and the buildings once housing it remain empty to this day, sitting like a great hulking insult on the majority of the North Side of the 100 block. The property has seen a succession of owners and failed redevelopment schemes, and the site is now held by the provincial government, which is quietly trying to sell it. Since 1993 the site has also been the locus of continuous and ongoing tensions about its fate. Community activists want the Woodward's buildings (there are five, none of any particular architectural merit, all monumental) developed as social housing. Typically, building developers see this idea as unprofitable unless

retail and upmarket housing are factored in. In the ongoing stalemate, the property flounders.

When it was open, Woodward's catered – popularly – to Vancouverites from every stripe, but the business was outflanked in the 1970s and '80s by the increasing sales clout and cut-rate profit margins offered by suburban shopping malls. Its closure ripped a hole in Hastings Street. The sheer size of the store effectively blacked out one whole inner city block. Add to this the repercussive effects the closure had on the neighbourhood's dependent shops and businesses, and a once-thriving commercial area was quickly made untenable. Into this retail vacuum a drug economy took over.[1]

Illicit drugs have always played a large role in Vancouver, more so than in any other Canadian city. In 1970, the LeDain Commission on non-medical drug usage estimated there were 4,000 heroin addicts in Canada. Sixty-two percent of these were located in British Columbia, the vast majority in Vancouver's Downtown Eastside. The reason may be no more complicated than the fact that Vancouver's port is the entry point for much of Canada's supply. Drugs here are cheap, and the British Columbia chapter of the Hells Angels, who run both the port and the drugs, is North America's richest.

In this arena crack was gold. Injection drug use had been escalating since the late 1980s as cocaine became increasingly popular, but the cost of coke was still prohibitive. Crack offered the first affordable, economical, and addictive alternative. Like shoppers on their way to the suburbs, users paraded to Hastings, and spawned a thriving market. Cars troll the street, and cruise past police officers who have long since given up hope of stopping the trade. For the police, success is measured in how well the drugs are kept corralled on Hastings between Cambie and Main, where they can expect the fewest complaints. Arrests are infrequent, and when they occur they are counterproductive, and result in pinch-hitting teams

deployed onto the streets to make up for lost productivity. Like a hydra, direct enforcement paradoxically crowds the streets with the incarcerated dealers multiplying replacements.

The image of artists fleeing this debilitated urban area like rats from a ship is ironic given their reputation as the shock troops of gentrification. Typically, artists form the vanguard of urban colonization. Cheap studio and gallery space in a city's "problem" area brings occupancy, and raises the perception of safety and hipness. In a few years, so the story goes, an influx of tertiary shops, boutiques, restaurants, renters, and loft owners follow. An area's vices, its drug dealing and petty crime, are bullied out by an influx of capital.

On Hastings Street, this model hasn't taken hold. In fact it appears to work in reverse. Why? Vancouver is no stranger to redevelopment and gentrification. Yaletown, Coal Harbour, and much of the central business district along Seymour and Richards Streets are undergoing an unprecedented development boom. These areas, once industrially zoned, are part and parcel of a wholesale reconfiguration and reimagination of the city's downtown core. Atypically, Hastings Street and Vancouver's Downtown Eastside have proven remarkably resistant to this development, and refuse to be included.

There are many reasons for this, but two stand out. The Downtown Eastside is already home to thousands of low-income residents. Unlike the abandoned industrial lands currently sprouting condo towers, there are hundreds of Single Resident Occupancy (SRO) hotels along Hastings Street and its vicinity that house a poor, established community. Many of those living on Hastings have developed a necessary ability to organize and resist those developments that don't include them. Their resistance, and occupancy, will remain well into the future.

Within this community, however, the drug culture grows. What is crucially different for redevelopment schemes in Vancouver that target

Hastings and the DES is that anyone with notions of "cleaning up" the area has met, in the financiers of the street's drug market, a powerful equal: an economic mirror that is entrenched, liquid, and largely immune to economic vagaries. The globalization of capital hasn't just benefitted the corporate industries bankrolling civic redevelopment and real estate speculation. The success of the Hastings drug market is because of outsourced labour, diverse supply bases, and a growing, hungry market looking to buy a cut-rate product. The Hells Angels have learned every lesson from their Downtown corporate cousins, and are as mercenary, globalized, and ruthlessly expansionist. Their arcade surrounds the 100 block, and for now the store is open.

Against this frame the buildings on Hastings deteriorate. Within them a community is largely ignored. At present, neither the buildings nor residents are necessary to the street level economy, or to shoppers buying out of a car window. Conflated with the dissolution rampant on the street, which is visible to anyone driving by, the residents of Hastings are harnessed to the rising disgust at the scars inflicted by the street's economy. As Denise Oleksijczuk poignantly makes clear in her essay, this disgust is misaligned, and has allowed for an incident of civic neglect whose result will undoubtedly mark Vancouver for years to come. What must hopefully coincide with any future acknowledgment of the crimes perpetrated against those who live and work in the Downtown Eastside is a reappraisal of the attitude that defines Hastings Street as a foreign land, and around which a border may finally be taken down.

Many individuals have contributed their time and energy to this project. I especially want to thank the writers for their invaluable input and hard work. My thanks to Svend-Erik Eriksen, Murray Bush, Martha Rosler, Ed Ruscha, and Thomas Struth for their kind permission to reproduce their work. Thanks to Michael Turner for helping to instigate this project, and

for bringing the Contemporary Art Gallery and Arsenal Pulp Press together to copublish this book. My deep gratitude also to Stan Douglas, Darren Kitchen, Deanna Ferguson, Tom Laviolette, Chris Haddock, Linda Chinfen, Donald MacPherson, John Mackie, Kate Bird, Donald Luxton, Aaron Vidaver, Claudia Beck, Andrew Gruft, Myfanwy MacLeod, and Zoe Lasham for their much needed assistance, feedback, and support.

Reid Shier

1. For a comprehensive look at this see Vancouver Carnegie Community Action Project's "On Hastings Street – 30 Years of Retail History in Vancouver's Downtown Eastside, 1970 – 2000," 2002.

"THE WORST BLOCK IN VANCOUVER" _Jeff Sommers and Nick Blomley_

When travelling east along Hastings Street in downtown Vancouver, the 100 block West Hastings marks the transition into the part of town that most people recognize as the Downtown Eastside, a place that, in 1998, *The Vancouver Sun*'s TV critic dubbed "Vancouver's worst neighbourhood . . . probably Canada's worst neighbourhood."[1]

Scarcely a month after this comment, Frances Bula, another *Sun* staffer, wrote a long article that proclaimed the 100 block West Hastings as the "worst block in Vancouver." The story, which followed an undercover Vancouver police team working the graveyard shift, described a scene of boarded-up, often deteriorating buildings and vacant storefronts that lined both sides of the street. This landscape provided a sinister backdrop for the work of the police in their largely fruitless efforts to bust the numerous drug dealers in the area. Despite a paucity of arrests, the attempt at least offered some official response to what Bula described as the "escalating anarchy and open drug market" that had transformed the block into a site that was not simply outside of "civilization," but beyond "the boundary into hell"[2] itself.

Less than a year earlier, in the same newspaper, two Vancouver police constables wrote an opinion piece concluding that the "epicentre" of the city's Skid Road district was three blocks away, on the 100 block of *East* Hastings Street, which they called "the worst crime block in Canada."[3] While the Bula article does note that the shift of "the worst" from East to West was but of recent origin, it overlooks some of its key implications. In particular, it misses the ways that the shifting geography of the "worst block in Vancouver" is part and parcel of the dramatic transformation of Vancouver's downtown peninsula and inner city districts over the past two decades. The evident changes in the 100 block West Hastings are inseparable from the deindustrialization of the downtown waterfront and the reorientation of the downtown economy toward tourism, information,

and producer and consumer services. Nor can they be understood without taking account of the widespread gentrification and redevelopment of the old working-class residential neighbourhoods in and around the urban core, which, in turn, is bound up with the new forms of inequality that come with the post-industrial economy.

An exploration of this new geography can begin by noting that the three newspaper articles on the "worst place" in Vancouver were written in the months following, and as part of, a moral panic that erupted in 1997. In the early autumn of that year, local health authorities declared that an epidemic of HIV was in progress among injection drug users *in the region*, but situated the Downtown Eastside at its centre. The rise of the panic followed more than a decade of escalating crises in the neighbourhood, beginning with the evictions of hundreds of tenants from single room occupancy (SRO) hotels prior to the Expo '86 world's fair, when slum landlords sought to upgrade their premises and cash in on an expected tourist boom.[4] A few years after this, city police began responding to development and gentrification pressures in other parts of the inner city by pushing the street-oriented drug and sex trades as close as possible to the vicinity of Hastings Street.[5]

Then, in 1993, the closure of the giant Woodward's department store, on the north side of the 100 block West Hastings, which for almost a century had been a shopping and social centre for residents of the Downtown Eastside and for people from all over the city, ignited a long-simmering confrontation between different social groups in the area. An alliance of local business groups and residential property owners lined up to support a proposal by a local property developer, Fama Development, to convert the building into 400 condominium units while community groups representing low-income residents, the majority of the local population, organized a vociferous and sustained opposition.

This polarization is bound up with the social and spatial transformation of downtown Vancouver and is thus implicated in the "decline" of the 100 block West Hastings. However, neither the social conflict nor the decline of that particular block can be understood without considering the moral panic over drugs and HIV. The panic situated the Downtown Eastside at the heart of the city's social and moral identity, magnifying the intensity of any events that have since taken place there. A characteristic of moral panic is the elision of boundaries between differing categories of phenomena and the blurring of causes and effects. In this case, understandings of injection (IV) drug use inevitably subsumed HIV and AIDS infection. Furthermore, both IV drug use and the disease were then conflated with the signs of growing poverty and marginality, such as homelessness, begging, and "squeegee kids," all of which had become increasingly visible in the downtown peninsula and inner city neighbourhoods over the 1990s.

The erosion of the boundaries between drug use and sickness, on one hand, and poverty, on the other, effectively pathologized the latter. In a bylaw designed to control begging, civic authorities deployed a kind of soft psychological rhetoric, suggesting that "drug and alcohol addictions and mental illness," were linked to begging, claiming that they were the "root causes behind the behaviour."[6] Other unofficial authorities were less restrained. "Drugs," the editors of *The Vancouver Sun* maintained, "are a cancer in the heart of the city."[7] Begging was also diagnosed as a "cancer" that was "spread[ing] its tentacles ... through the body politic."[8] "We have to uproot it because we are being affected,"[9] asserted one business representative. Such reports argued that beggars, criminals, and homeless people were also likely to be drug addicts.

The pathologization of the poor turned into the pathologization of the entire neighbourhood, as the Downtown Eastside itself became the

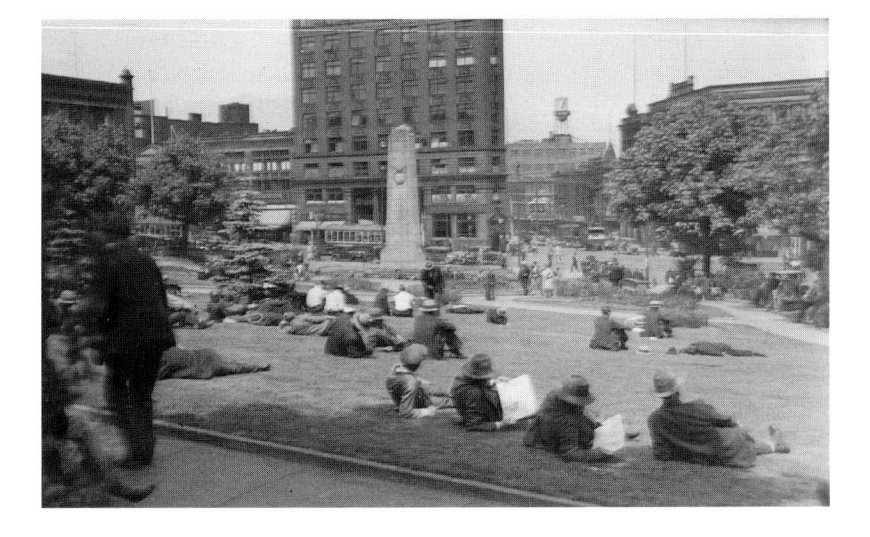

Men resting in Victory Square, Labour Day parade, 1935

Courtesy of Vancouver Public Library Special Collections # 13317

wellspring of this social malaise. With the moral panic escalating, the whole population of the district was perceived as a bunch of dope fiends. A newspaper article declared that "6,000 to 10,000 addicts . . . frequent the seedy hotels and back alleys in the Downtown Eastside,"[10] heedless of the fact that the population of the neighbourhood was only about 8,000 people. According to the police constables cited earlier, the district was a "disease-ridden enclave of filth and desolation," resulting from "an influx of new denizens – career criminals whose only solace is prolific intravenous drug use where the price is humanity and their dignity."[11]

The rhetoric of pathology bridged the body of the urban outcast and the social body of the city in three crucial ways. First, the neighbourhood was seen as a site that actually *caused* the problems evident among the local population and within the built environment. The deplorable conditions of many of the single room occupancy (SRO) hotels received some attention in this regard: "The garbage. The smell. The rats. The cockroaches. The filthy toilets."[12] One addicted woman was reportedly driven by her cravings to a "ramshackle apartment in the Downtown Eastside" where she lived in a "vermin-infested room" which "stank."[13] Living in such an insidious zone was enough to "drive . . . those who have barely reached adulthood to find slow suicide in the form of AIDS."[14] Clearly, this is an evil place.

Secondly, these local pathologies threatened the rest of the city. The poor and drug addicted were constituted not only as victims of disease, but also its carriers, agents of infection who literally caused urban decay. In a formulation reminiscent of the (in)famous broken windows theory of neighbourhood decline, both media and government explanations of the Downtown Eastside situated poverty and drug use as the central causes of the disinvestment in the built environment, manifested in boarded-up buildings and empty storefronts, for-sale signs, and vacant lots used as carparks. In this reasoning, the sickness of drug addiction, inextricably linked to poverty, infects the local environment itself.

Squatters' beds, TV, and lights, Woodward's building, September 20, 2002
Photo: Reid Shier

This danger, however, was not confined to the Downtown Eastside. Like any urban population, the people who live and work there are mobile. The redevelopment of the DES, imminent in the proposed Woodward's condominium project, threatened to disperse a population and their problems to other parts of the city. Such an event would mean that "we are doomed to have its plethora of societal problems re-emerge in outlying areas."[15] The "denizens" of the Downtown Eastside would simply replicate their neighbourhood somewhere else. In other words, the pathology of the Downtown Eastside could spread.

The wider city of Vancouver, thirdly, imagines the outcast population of the Downtown Eastside as morally isolated from the rest of the city. The notion of neighbourhood decline as a relationship between poverty, drugs, and disease situates the area as a place apart and radically different from anywhere else in Vancouver. This difference has been expressed most succinctly through the use of the term "ghetto" to explain the events in this part of town. In a flourish of rhetorical excess, a range of commentators have attempted to draw equivalence between the Downtown Eastside and a "U.S. inner-city ghetto . . . with a wide range of graffiti and denizens including skid row drunks, spaced-out junkies and punk street kids." The 100 block West Hastings and adjacent blocks "provide such a contrast to the shiny, happy business core," one writer argued, that they might give the "stray tourist" (as if they were pets) cause to "mistake this neighbourhood for Harlem."[16]

The word ghetto, of course, refers to ethnically homogenous zones of enforced racial exclusion. Given the contemporary absence of such a phenomenon in Vancouver, local proponents of the term point to the segregation of the poor in the neighbourhood, claiming that the level of services on offer has created a "service-dependent ghetto" in the Downtown Eastside that somehow beckons like an Eldorado for the impoverished or, as

one journalist put it, a "dumping ground for the city's ills and government dollars."[17] Such thinking impresses itself on officialdom. Civic planning committee members, in one example, expressed alarm about "an influx of facilities targeted to clientele at the lower end of the socio-economic scale, which cater to the socially disabled and consequently have been known to attract an undesirable element."[18] Here, poverty is likened to disability (i.e., pathology) and criminality.

The use of ghetto terminology in this context has significant implications for the neighbourhood, particularly because it provides a means of racializing poverty and, therefore, subordinating the poor as exotic and potentially menacing outcasts. Wrenched out of its U.S. context, the term dovetails with the equation of addiction, poverty, and disease by evoking anxieties of a threatening, pathological underclass that is spatially isolated from the rest of the city, socially detached from "mainstream" values, and ready to erupt at any time from its dark enclave. In 1998, City Councillors voted for a report in which civic bureaucrats, presenting no factual evidence, claimed that "the neighbourhood is becoming more and more isolated from the rest of Vancouver . . . a haven of drugs and crime, fewer and fewer people who live elsewhere go there now."[19]

However, claims of isolation jar against the experience of a place where expensive condos stand just around the corner from a drug market where cocaine and heroin are openly offered and exchanged. Tourist shops operate just down the street from (and tourists wander through) drug users smoking rock or "fixing" or occasionally "tweaking." Increasingly high-priced, renovated heritage houses are located in the same neighbourhood as cheap rooms, welfare offices, and food lines. Meanwhile, the local and international media – including television and film – never tire of Downtown Eastside scenes. So familiar – and notorious – has the neighbourhood become that Hollywood production crews are an almost

The 100 block West Hastings looking northeast from Cambie Street (ca 1900)

Courtesy of Vancouver Public Library Special Collections # 5208

Police on horseback on 100 West Hastings during Post Office and Art Gallery sit-down strike, 1938
Courtesy of Pac Press and Vancouver Public Library Special Collections # 1304

constant presence in the area's back alleys. Many, if not the majority, of local residents may be economically and politically marginal. But if this place is an isolated ghetto, it must be the most accessible and well-known one in history.

The twists and turns of this stigmatization can be traced for most of the twentieth century. Hastings Street east of Cambie, and its environs, has long been problematic for civic authorities. In his history of the city, *Making Vancouver*, Robert McDonald discusses the strategic importance of streets and parks as sites where the working class and immigrant inhabitants of the city's East End could assert their presence and contest the dominance of the local Anglo elite that owned the buildings and properties where they lived and worked. McDonald describes the angry letter sent to Vancouver City Council in 1904 by the management of the newly opened Woodward's department store, at Hastings and Abbott, complaining that its customers were prevented from entering the store by the crowds of people congregating on the street outside, selling and buying labour newspapers, listening to radical speakers, or simply enjoying the ambience. In the public spaces of the area, the excluded population of Vancouver created its community in counterpoint to the privatized society of property.[20]

In the 1930s, during the Great Depression, Hastings Street became the main thoroughfare for demonstrations supporting full employment policies, bracketed on one end by the Post Office (now the Sinclair Centre) that was occupied by unemployed men in 1938, until police on horses evicted them using batons and fists and, on the other end, the Carnegie Library (now Carnegie Centre), which was occupied for two months by relief camp strikers in 1935 prior to the On-to-Ottawa Trek. In between, Victory Square was the site of a police riot in 1935 when, following a reading of the Riot Act by the Mayor (who had only recently dined with officers of the Third Reich's navy aboard their visiting warship), constables attacked an assembly of unemployed men.[21]

But the history of the excluded is not just a story of protest. Indeed, that protest was bred in circumstances of pain and deprivation. Hastings Street was also the main thoroughfare of a district with a dubious, even dangerous, reputation. It was lined not only with theatres, shops, and cafés that some commentators now refer to with evident nostalgia; it was also the home of bars, brothels, and gambling clubs. And, as the century wore on, many of those cafés became important retail outlets for Vancouver's always bustling heroin trade.

This was also the area where Chinese and Japanese immigrants were segregated in ghettoized neighbourhoods that were occasionally assailed by "anti-Asiatic" rioters. In 1917, the Chief of Police was killed by a morphine addict on East Georgia Street, cementing, for the next fifty years, the reputation of the East End immigrant neighbourhood (now known more genteelly as Strathcona) as Vancouver's slum district. By the decade of the Depression, much of the area's housing, particularly that consigned to Chinese residents, was considered "unfit for habitation," while those inhabitants were often characterized as the "dregs of the population."[22]

In the two decades after World War II, the vision of an unruly, perilous territory crystallized in the minds of civic authorities and, ultimately, in the public imagination as a place called Skid Road. The name was first used in logging to describe the corduroy roads along which fallen trees were "skidded" to the mill.[23] In Vancouver and Seattle, it was later applied to the agglomerations of bars, hotels, and bordellos that sprang up near logging camps and mills to service their workers. In a frontier town like Vancouver, such a place implied fun, so much so that the midway at the 1913 Pacific National Exhibition was named Skid Road.[24] Forty years later, however, the term had acquired a much different connotation.[25]

In his memoir of boyhood in 1940s East Vancouver, Rolf Knight highlights the intricate connections between the industrial waterfront and

the local ways of life it supported. A distinct social and cultural milieu formed around the diverse industries on the Burrard Inlet and False Creek waterfronts, a subculture that was centred between the urban and frontier economies. Integral to this was the area's importance as a residential and recreational space for many of the people – overwhelmingly men – employed in this industrial complex. As Knight puts it:

> Life along the No. 20 [street car] line was not really typical of the city as a whole by the 1940s. . . . [B]y then the bulk of Vancouver's population was already well removed from direct involvement with docks and harbour traffic, rail lines and boneyards. Already the rattle of freight trains, the whine of boom winches and the clunkering of beehive slab burners were probably exotic (or just annoying) sounds to many. The loggers and miners, retired prospectors, camp workers and seamen who made up so large a proportion of our [waterfront] city were really a small minority.[26]

Following World War II, a slow decline began in the neighbourhood as its central role in warehousing, transportation, and a host of manufacturing operations that relied on or supported hinterland resource extraction began to dim. Over the same period, there was also a shift in the structure of the labour market. Consolidation in the ownership of resource industries, on one hand, and increasing unionization of the workforce, on the other, reduced the demand for the migrant workers who lived in the neighbourhoods around the downtown waterfront. At the same time, waterfront industries began to relocate to cheaper land far from the downtown core.

The restructuring of the waterfront-hinterland industrial linkages propelled the ebbing of the subculture that had formed around it. Increasingly, this neighbourhood was no longer identified through work,

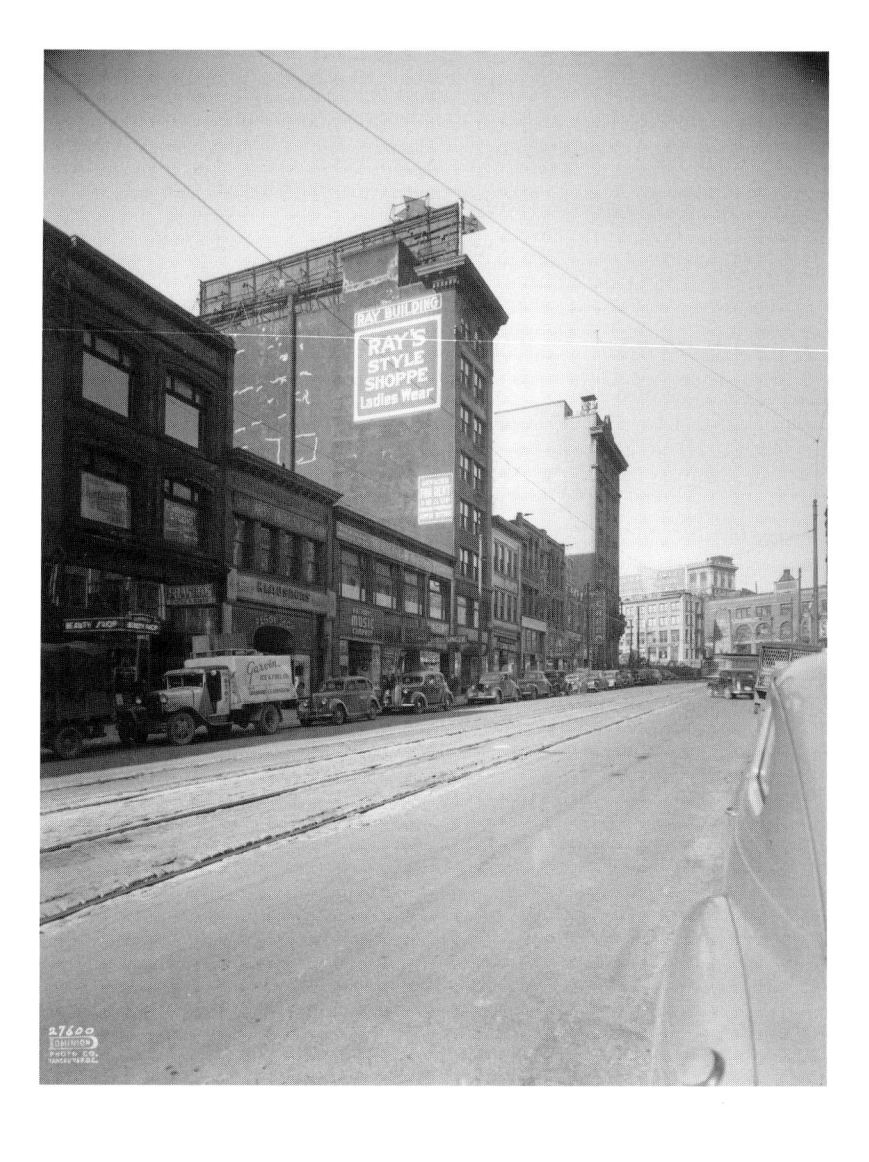

South side of 100 West Hastings, February 23, 1944

Courtesy of Vancouver Public Library Special Collections # 26128

but rather in terms of the morally dubious nature of other activities that took place in the area such as gambling, and especially drinking.

Skid Road made its first entry into local headlines in the early 1950s when observers began to describe the area north of Hastings Street between Cambie and Gore in terms strikingly similar to those used in recent accounts. In his 1950 plan for rebuilding the neighbourhood he dubbed Strathcona, housing reformer and UBC Professor of Social Work Leonard Marsh had already distinguished between what he saw as the basically respectable but poor family neighbourhood east of Main Street from the rowdy, disreputable zone to its west.[27] In this latter area, journalists witnessed rampant moral corruption amid a rapidly deteriorating urban environment. A 1952 exposé in the *Province* newspaper described an "ugly, squalid quarter of viciousness"[28] that lay between Hastings Street and the waterfront. According to the writer, the area was "infest[ed] with centres of immorality" that were populated by "the lowest in humanity," including the "homeless 'canned heater' and 'alkey' . . . criminals, alcoholics, drug addicts and sex perverts . . . juvenile delinquents . . . pick-up girls and prostitutes." It was also an unhealthy place. "Tuberculosis and other infections" were rampant in this "unsound, unsanitary cauldron," physically contaminating the already socially degenerate inhabitants.[29] In fact, it was so bad that another writer noted that decay permeated the very air, as "the oily smell of the vast waterfront mingle[d] with the stench of the city dump and the odor of stale alcohol."[30]

By the mid-sixties, this corruption and decay threatened to engulf Hastings Street. In 1965, alarmed at a sharp decline in property values, local business and property owners formed IDEAS – the Improvement of the Downtown East Area Society – to press for government action to help them "halt the skid."[31] *Vancouver Sun* editors wrote that:

> *[d]istress signals ha[d] been flying for a long time. More than three years*
> *ago, central Hastings, in particular, was recognized as a disaster area.*
> *Some stores had been vacant for years, and more were emptying. Land*
> *assessments had been cut by as much as 50 percent with accompanying*
> *loss in tax revenue. Cheap hotels, dingy beer parlours, shooting galleries,*
> *the claptrap that spells decay, threatened what was once the town's main*
> *drag.*[32]

In the late 1950s and early 1960s, the downtown business and property-owning elite dominated the city through its control of the ruling civic party, the Non-Partisan Association. As in other North American cities, the anxiety of elite groups was rising over the state of inner city districts, especially the Central Business District (CBD). The downtown retail trade, in particular, was threatened by suburbanization and the proliferation of shopping malls. The constricted street network, largely designed before the car was invented, limited automobile access to and parking in the downtown peninsula. The aging building stock was considered unsuited to the needs of a modern downtown. On top of this, the industrial nature of much downtown space was seen as a disadvantage in competing with the burgeoning suburban shopping complexes.

In response to these threats, the City instituted a modernization program. What its planners called "the collar of slum and blighted properties . . . to the south and in particular to the east" of the downtown area required "surgical methods of cutting out old buildings and rebuilding as part of a comprehensive scheme of redevelopment."[33]

Thus, on the same day that the *Sun* "Welcome[d] . . . the IDEAS Men," its readers were treated to an embarrassingly gushing front-page story announcing a "skyscraper-studded plan . . . for the waterfront."[34] Project 200, as it was called by its private developers, was to include fourteen

office towers, a thousand apartments, a six hundred-room hotel, and retail sites along the waterfront. The most important element of the plan, and on which much of its feasibility hinged, was a feature that was euphemistically called a "waterfront roadway."

This "roadway" was, in reality, part of a long but furtively-planned freeway system designed to connect Highway 1 with the Upper Levels Highway, on the city's North Shore, via downtown and a new bridge across Burrard Inlet. Its construction would necessitate the demolition of large parts of the Downtown Eastside, including most of Chinatown and parts of what is now known as Gastown. Indeed, this was one of its objectives: following what it viewed as the successful initiation of urban renewal via demolition and redevelopment in Strathcona, the City was proposing a second urban renewal scheme in the downtown peninsula between Main and Richards Streets that involved turning much of the area into offices and parking lots serving the uptown commercial district. The cars that used the freeway to gain access to downtown needed to park somewhere. Why not here? It was wasted space.

Unfortunately for the planners and politicians whose careers, as it turned out, hinged on this development, it was unveiled at the most inopportune moment possible. The City's plans rapidly came under fire, initially from social workers, who maintained that civic plans would merely displace, rather than fix, the area's problems. One well-meaning critic of civic policy contended that the Skid Road of the 1960s was "a haven for the rejects of society [like] the alcoholic, addict and sex deviate

The Vancouver Sun building, 2002
Photo: Milutin Gubash

[who] cannot cope with the demands and frustrations of general society, but . . . can function within their own group."[35] Consequently, Skid Road is "not just a geographic accident [but] a hard core of human failure." Rather than eliminating the deviant impulses that are responsible for the existence of such a place, this critic claimed, urban renewal would only move it somewhere else. Another commentator complained that "putting the same men in new buildings won't help," but neither would "moving people to new areas."[36] One area worker put the case more quaintly: "'You take a girl, dress her up pretty and put her in a new home in [suburban] Burnaby. It doesn't work. It's like Buckingham Palace to her; she's out of her element'."[37] Reinvestment in land, infrastructure, and building stock would all be for naught unless there was a concomitant rehabilitation of the humans involved.

But such arguments were only a prelude to later, more decisive opposition to urban renewal. The late 1960s were a period of intense social unrest in Vancouver, particularly in the inner city districts. From Kitsilano to the West End, Grandview, Mount Pleasant, Fairview, Strathcona, and "Skid Road," the youth counterculture converged with an emergent community organizing movement to spark a wave, first of rebellion, and then of intense social innovation. The freeway and urban renewal provided a key site of oppositional focus, as disparate groups ranging from Chinese-speaking residents of Strathcona and Chinatown merchants joined together with

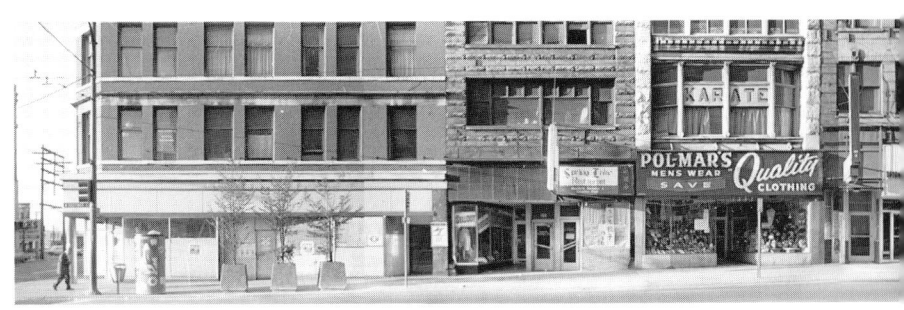

Composite view of 100 West Hastings, 1974
Photo: Svend-Erik Eriksen, courtesy of the artist

yippies and university professors to eventually force the City to relent on its program. (In one of the many ironies that abound in this part of town, the corporate offices of *The Vancouver Sun* are located in the only piece of Project 200 that was ever completed.)

At the same time, the contemporary expansion and reform of the welfare state provided a fiscal basis for the practical realization of oppositional social ideas. Much of the present-day social infrastructure of Vancouver was organized during this period as non-profit organizations proliferated in response to community demands for services and political representation. In the Skid Road district, this social innovation emerged through a conjunction of opposition to urban renewal, anti-poverty organizing, and activism over housing displacement.

In 1973, the Downtown Eastside Residents' Association (DERA) was formed to demand official recognition of the area as a residential community, a proposal which, at the time, was nothing short of revolutionary. DERA sought to enforce this claim through a series of campaigns that were designed to improve the living conditions of people who, as the denizens of Skid Road, were generally represented as the quintessential outsiders. Its members picketed slum hotels and confronted cabinet ministers about poverty; they agitated for social housing and tighter restrictions on alcohol in an area which then had eighty percent of the licenced bar seats in the city. At the same time that DERA took on local

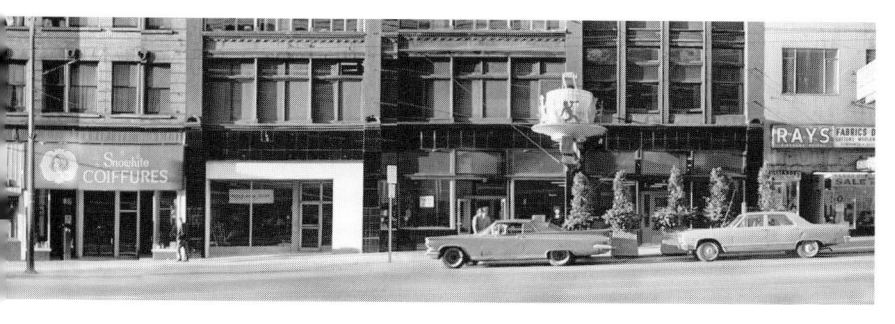

businesses that profited from criminal activities, it also organized tours of
the prosperous districts on the west side of the city, urging its members to
compare the views from their own windows with those afforded residents
of more affluent neighbourhoods, and to question the reasons for this
difference.

While DERA made plenty of enemies through it all, it also made
friends, including many in the press, who helped its organizers transform
perceptions of the Downtown Eastside. In 1984, four years after the
opening of the Carnegie Centre in the building which once housed the
old city public library, a front-page headline in the *Sun* proclaimed: "Skid
Road Cleans Up Its Act."[38] The neighbourhood was improving, the writer
argued, primarily because residents, with the help of state resources, were
tackling their own problems. Only a decade before, these same residents
had been seen as social pariahs who should be removed from the area. As
a result of DERA's efforts, they were now treated as citizens with a right of
occupation who were entitled, regardless of their level of income, to decent
housing, a community centre, and adequate health services, and to at least
the expectation that the City enforce its own building standards in the slum
hotels where so many of them lived.

Advancing a claim to the right of habitation requires more than a
material improvement in living conditions. It also necessitates what urban
geographer David Ley has called a "cultural-symbolic struggle"[39] in which
history is a central element. The neighbourhood was renamed, but so too
were the people who lived there. "Skid Road" became the "Downtown
Eastside," which was not just a residential community, but a community
with a past inextricably bound up with the Vancouver waterfront and its
position at the nexus of the city and B.C.'s hinterland resource industries.
The new appellation Downtown Eastside sought to counter the marginal
status to which local residents were relegated as denizens of Skid Road.

People who were once seen as derelicts and deviants were now being recognized as former loggers, miners, seamen, railroad workers, waitresses, cooks, longshoremen, millworkers, and others associated with the economic expansion of the west. "They are poor now," wrote one journalist, "but before their bodies grew old and began to break they were working to help build this country."[40]

DERA was formed simultaneously with, and in some respects in response to, another shift in the area's identity. The renovation of what was then known as the Old Granville Townsite, which tourist boosters would redub Gastown, gave a decisive southward shove to Skid Road, displacing its centre away from Carrall Street between Water and Cordova Streets onto Hastings. Until then, the city's small community of heritage connoisseurs, which was composed primarily of a small group of minor property-owners, urban planners, architects, and the Community Arts Council, was largely unheard of and unheeded. However, the rebellion against the freeway and urban renewal plan provided an opportune convergence of interests with ethnic organizations and countercultural groups to give Heritage a new significance in opposing "major urban surgery, razing and rebuilding" the inner city.[41]

The proponents of heritage renovation were harbingers of the transformation, two decades later, of the Central Business District (CBD). Such renovation however, was more liberal in its initial conception than in its ultimate manifestation. The renovated Gastown, according to its early middle class professional visionaries, would be a site of inclusiveness, based upon the "fundamental principles" that should inform all urban design: "choice . . . new experience . . . access by people . . . identity . . . human dignity . . . integration . . . diversity . . . visual enhancement . . . quality of life."[42] In justifying heritage preservation, Gastown's proponents argued that: "The widest range of choice for each person to participate and

Looking south from Hastings at Abbott, 1974
Photo: Svend-Erik Eriksen, courtesy of the artist

experience urban life is the basic fabric of a city's cloth on which must be woven the two most powerful influences in a city's future: movement – communication; education – leisure."[43]

And yet, twenty years on, this vision of a democratic space was subordinated to the economy of property. The problem it proposed to resolve, urban blight, was virtually the same as that of the centralized, bureaucratic, and corporate urban renewal programs it opposed. Heritage preservation was thus, more than anything, an alternative economic and property development strategy, rather than the innovative social and cultural approach which it claimed to be. In many respects, the renovation of Gastown marks the re-animation of downtown urban renewal. Four hundred SRO rooms were lost between 1968 and 1975, displacing large numbers of low-income and socially marginal residents.[44]

This counterpoint between the rise of DERA and everything it represents, and the imperatives of revitalisation as embodied in the renovation of Gastown, has been at the heart of the debate over the Downtown Eastside for the past thirty years. Despite the construction over that time of social housing, increasing provision of services, and more rigorous enforcement of City bylaws, the Downtown Eastside continues to be stigmatized as "Vancouver's worst neighbourhood."[45]

Yet there are significant differences between contemporary invocations of the Downtown Eastside as a ghetto and its earlier derogation as Skid Road. Importantly, as the result of much effort, the quality of life for many residents of the neighbourhood has improved. At the same time, however, the optimism that was generated by the countercultural revolt of the 1960s and 1970s has given way to the cynicism and tension created by deepening social inequality. As in so many other cities around the world restructured by the pull of global economic competition and the push of welfare state retrenchment, Vancouver has seen the bounding of a so-called "distressed

neighbourhood" that functions as the site for intensifying regulation of the outcast poor.

Income inequality increased across both the city of Vancouver and the metropolitan area between 1970 and 1990.[46] Even so, the stark contrast between the Downtown Eastside and the rest of the city is startling. The median household income in the region went up by 4.7 times over the twenty-year period to 1990. In the Downtown Eastside, it increased by less than half that amount. In other words, the median household income in the neighbourhood effectively fell in comparison with the rest of the city, from nearly half the regional median in 1970 to less than a quarter by 1990.[47]

Taken in abstraction, numbers like this seem relatively weightless. Yet, such statistics bring cogency to any consideration of the "worst" block in the "worst" neighbourhood in the city. This is especially so if we recall that the spectre of the 100 block West Hastings emerged in the literal shadow of the real estate and construction boom which has transformed the social and economic landscape of the downtown peninsula and inner city. Since 1989, housing for 25,000 new residents, generally in glittering new high-rise condominium towers, has been built downtown, even as Vancouver's housing prices have become the most expensive in Canada. And the presence of those new residents has driven the redevelopment of the urban core from a predominantly commercial and industrial space to a consumer paradise. Wherever the new condo towers have emerged across the CBD and the adjoining West End, so too have appeared cafés, bars, shops, and restaurants to serve the new inhabitants.

Despite such redevelopment having reached to within one block, the 100 block West Hastings Street and the area around it have, unsurprisingly, given the statistics noted above, remained impervious to its embrace. More surprising, perhaps, are those political, bureaucratic, and corporate decision-makers considering this resistance to redevelopment, rather than

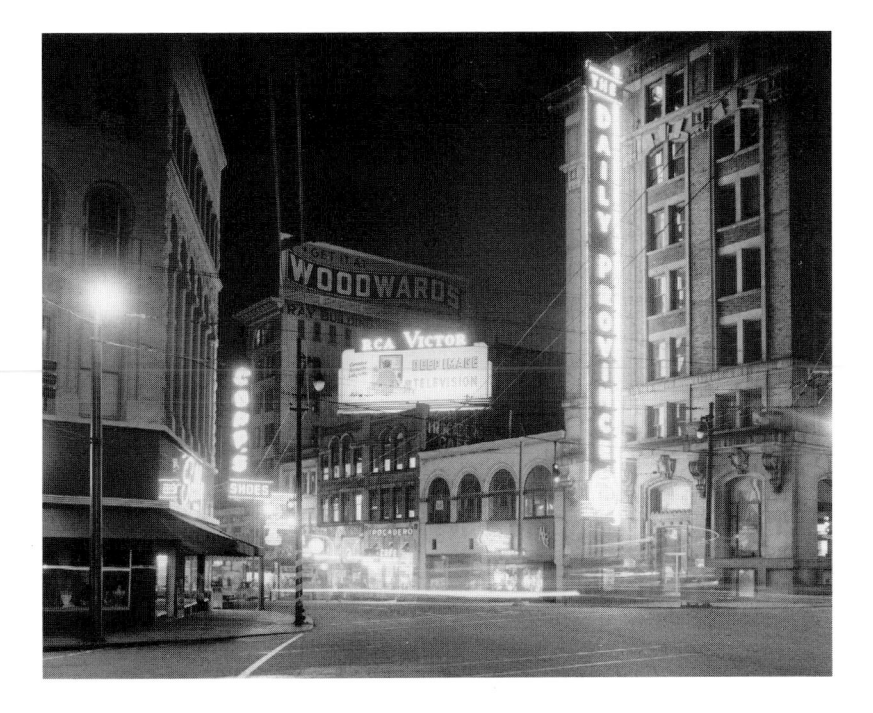

Looking east on Hastings from Cambie Street, 1955

Photo: Vic Spooner, courtesy of Vancouver Public Library Special Collections # 82829-A

the poverty of its inhabitants, to be the main problem with the Downtown Eastside. Today, the poor are important only to the extent that their presence can bring down property values and discourage development, rather than, as thirty years ago, threaten rebellion.

The policy problem has thus become a question of how to extend the affluence that is evident in the rest of the urban core to this small but resistant corner. Practically, the question is how to minimize the visibility of outcast poverty, to render it innocuous and non-threatening to the values of private property. In much of the Central Business District, private police have become a fixture, as business groups seek to exclude, as much as possible, those whose appearance and conduct are at odds with the conspicuous consumption that is now the *raison d'être* of downtown Vancouver. In this respect, the original designers of Gastown, with their clarion call for increased policing in order to improve "shopping conditions . . . by minimizing contact between the shopper and the destitute,"[48] were pioneers.

It is unsurprising that the Downtown Eastside, rather than the new uptown or shoreline condo districts, has become synonymous with the symptoms of the social divide that is now characteristic of almost all global cities (or, in Vancouver's case, cities with elites that have global aspirations). Instead of the unfettered consumption and spiraling housing prices that mark the affluent side of the widening gap, it is their inevitable corollaries, begging, homelessness, food banks, soup kitchens, and the expanding street economy centred on the drug and sex trades, that have been constituted as the indicators that something is wrong in Vancouver. And, as all these things grew in prominence and visibility during the nineties, their appearance in other parts of the city was increasingly seen as a "spill-over" or "displacement" effect from the Downtown Eastside, as if they were somehow the exclusive attributes of only one place in the entire city. One set

of commentators declared: "We have all felt the pervasive influence of the area when we become victims of break-ins, car thefts, and other crimes,"[49] as if the Downtown Eastside were the sole source and reason for such conduct.

In this context, the use of the term "ghetto" to explain the Downtown Eastside has implications more ominous than just stigmatization. Its use has accompanied a second line of explanation that seeks to make sense of the kinds of conflicts that have developed around places like the Woodward's building or issues like begging and the sex trade. This is what Neil Smith has called the myth of the "new urban frontier" that casts poor, rundown inner city neighbourhoods, in the manner of the old west, as wild, dangerous, and, ultimately, empty spaces, ripe for (re)settlement.[50] The rhetoric here is rich and varied: The Downtown Eastside is a "war zone"[51] or "ground zero,"[52] where, as noted, one finds oneself crossing the "boundary into hell": All this from sympathetic writers. The myth of the frontier is not the same as a ghetto discourse, however. While both constitute a view of poverty through the same ideological lens, situating the poor, rather than the condition of poverty, as the problem, the notion of the frontier implies confrontation and transformation, rather than isolation and stasis.

The frontier mythos takes us into the heart of Vancouver's social divide. Quite simply, the downtown peninsula and the surrounding districts have becomes sites of confrontation between incoming middle-class settlers and impoverished residents who live in sro hotels, rooming houses, basement suites, and tumble-down houses owned by slum landlords. The metaphor of the frontier provides a framework that justifies the deliberate and incidental measures taken to make such an environment amenable to its new inhabitants. But it also speaks to a much deeper, ingrained middle class and elite response to the disorder of the city. The imaginary of the urban wilderness heralds the domestication of urban life.

100 block West Hastings looking west from Abbott Street, 1908
Courtesy of Vancouver Public Library Special Collections # 6782

Middle class reformers in mid-nineteenth-century U.S. cities, shocked by their encounters with the urban poor, sought to recreate the hierarchical social order of the villages from whence they came. Their Victorian counterparts attempted to contain and inoculate themselves from the "criminal classes," while a few decades later, on both sides of the Atlantic, the middle and skilled working classes began to retreat from the chaotic, heterogeneous streets of the central city into a closed, increasingly suburbanized, and conformist domesticity. In much the same way, the new middle class of professionals, technical experts, managers, and entrepreneurs of the post-industrial service and information economy, seeks to order a rather messy inner city into a consumption and pleasure zone. Simultaneously, these classes wish to protect themselves from the outcast poor – the beggars, drug addicts, homeless, and sex workers – who roam the same city streets they claim. The role of these "urban pioneers" (although in Vancouver, they are hardly pioneering) is twofold: by the very power of their consumption they will apparently call the new city into being; and by their presence, they will provide an example of civilized behaviour for the unruly outcasts around them. And, like the western frontier of old, when the incoming settlers encounter resistance, they immediately demand measures for its extirpation.

This confrontation takes place across the inner city with varying degrees of intensity, flowing in some places and ebbing in others as the new city is constructed on top of and, wherever possible, within the remains of the old industrial city. It is not simply a question of what kinds of activities take place on the street and in the buildings or how much money flows into property development. Indeed, it is partly because low-income groups are overpowered in the arena of capital that this contest shifts into the realm of memory and meaning. The streetscape of the 100 block West Hastings and the imposing Woodward's Building have achieved iconic status in this

Woodward's exterior, Abbott and Hastings, March 23, 1949
Courtesy of Vancouver Public Library Special Collections # 27900

confrontation. For each side, the potential of this site to influence future development of the neighbourhood seems obvious. Also, for each, the block signifies much that is wrong with this part of Vancouver, perhaps even with the city itself. And so, it is not only the territory and buildings that are contested in a place like this. The stories about the reasons for its current state have also become objects of conflict. The drug panic and the "ghetto" are pivotal in this context because they provide analytical frameworks through which the situation can be parsed and judged, support mobilized, decisions made, and policies formulated.

What is in question is the very meaning of the built landscape of the Downtown Eastside, and thus, the history and future of the neighbourhood. For one constituency, the visible decay and emptiness of the buildings evokes despair and anger. The boarded-up streetscape of Hastings Street, with its aging "For Sale" signs, stands as a constant reminder of the ruination of urban space by the nameless denizens of Skid Road: broken bodies and a scarred and dirty landscape combine. Overlaying this is a sense of loss, deepened by mythologized memories of Hastings Street's past as a shared space of commercial vitality. The city has been "taken" from its inhabitants by the poor: as commuters speed down Hastings Street, they are invited to reflect that this is no longer "our" neighbourhood. The only way the valued landscape of the Downtown Eastside can be saved, on this account, is with the removal of that which threatens it – the poor – and its replacement by citizens who are better equipped to reclaim its potential, both economically and historically. Property owners, attuned to "heritage" values, are to be encouraged to homestead the wilderness, and recapture this space and its authentic meanings.

Abondoned "Context Photo Board," Fama Holdings Ltd.; collaged photographs on foam core, including panorama of 100 block West Hastings, September 20, 2002

Photo: Milutin Gubash

The closure of the Woodward's department store is particularly important in this account. Mythologized as a happy, familial store that united Vancouver society (remember the window displays at Christmas! the busy and happy crowds of shoppers!), the dark and boarded-up store, and the threatening streets and people that surround it have come to crystallize this sense of dispossession. Fama's original proposal for Woodward's was vigorously supported by local speculators. Here, at last, was a hardy pioneer, willing to take a risk and reclaim a space.

But the urban frontier, like any boundary, has two sides. Frontiers have long been sites of struggle over land, power, and meaning. While dominant accounts treat the buildings of Hastings Street as part of Vancouver's historic entitlement, "stolen" by an urban underclass, community-based accounts imagine the built landscape as morally 'owned' by local residents, to hold in trust for the good of the neighbourhood and the wider city. The built landscape of the Downtown Eastside is thus mapped very differently by those of the neighbourhood. For locals and anti-poverty activists, not to mention non-activists, the declining streetscape is not deemed to be the fault of the poor, but of speculators, content to sit on empty properties while they await the pioneers.

From this position, the closure of Woodward's was indeed a loss: its disappearance "took a large chunk from the heart of the community and out of Vancouver's history. Since then, developers and speculators have been

Abandoned architectural redevelopment models, Woodward's site development office, September 20, 2002
Photos: Reid Shier

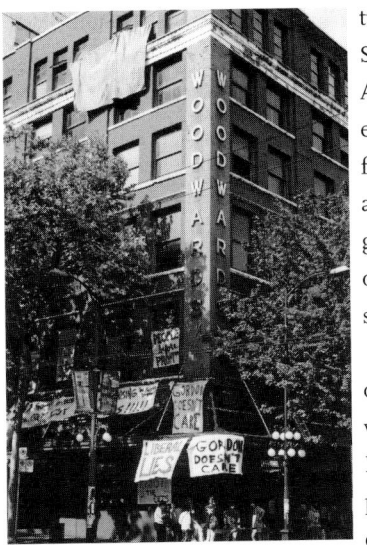

turning the once lively West Hastings Street into a boarded up and bleak American style inner-city. The dark empty buildings, the loss of street and feelings of safety, and the neglect are a testament to their indifference and greed."[53] Again, we see the imaginary of the ghetto, deployed here for somewhat different purposes.

Histories of shared use and occupation have imbued this landscape with moral and political meaning.[54] Following the announcement of plans to turn the building into condominiums, opponents argued in a flyer: "We have given Woodward's its history. Now we are coming together to *reclaim* that history . . ." Woodward's is again remembered nostalgically, but is now memorialized as a valued space of shared interaction and communal life for a low-income population who were often confined to SRO units. Woodward's was "one of those places people could go and feel like an ordinary person rather than a poor person," notes one local commentator. To that extent, it becomes a building claimed by and for the community: "We're not going to let go of the Woodward's site, even if someone else does own it" insists one area activist.[55]

Part of the community-based concern over the deterioration of the streetscape and Woodward's, in particular, reflects the realization that the landscape can be read in different ways in frontier spaces like the Downtown Eastside. Residential SRO hotels – that speak to a complex history of working-class marginalization, struggle, and survival – can

Woodward's squatters protest, Abbott and Hastings, September, 2002
Photo: Murray Bush CCAP photo

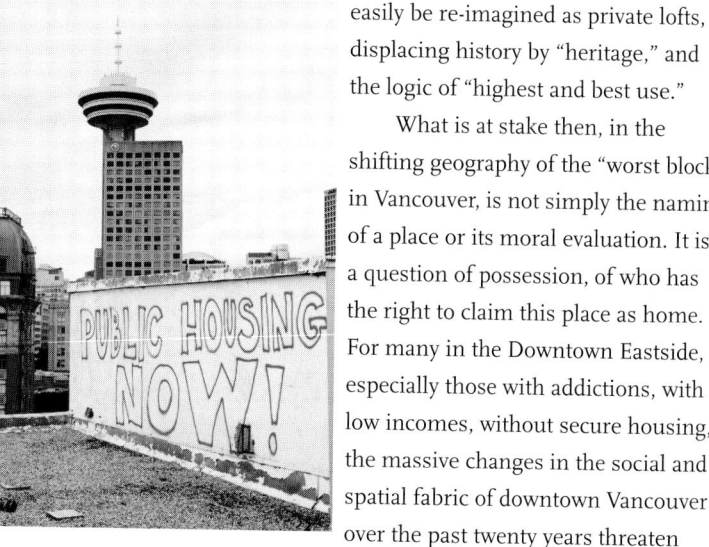

easily be re-imagined as private lofts, displacing history by "heritage," and the logic of "highest and best use."

What is at stake then, in the shifting geography of the "worst block" in Vancouver, is not simply the naming of a place or its moral evaluation. It is a question of possession, of who has the right to claim this place as home. For many in the Downtown Eastside, especially those with addictions, with low incomes, without secure housing, the massive changes in the social and spatial fabric of downtown Vancouver over the past twenty years threaten to reverse the hard-won gains of DERA and other community groups in the 1970s and 1980s. This isn't only a question of material displacement. It is feared that those moving into the neighbourhood will also facilitate their cultural dispossession of low-income inhabitants. As one activist noted, "there is more than one way to lose a neighbourhood. You can lose it through homelessness, but you can also lose it by just outnumbering people, just pouring in".

For others in the neighbourhood, particularly business organizations and groups of residential property-owners, the transformation of the rest of the downtown peninsula offers the potential of a shining future for the Downtown Eastside. What stands in the way are drugs and miscreants. For these interests, a police force empowered to move problems out of the area will result in a flow of investment into the buildings and properties which have so long stood vacant or neglected.[56] In this regard, 2000 – 2001

"Public Housing Now!" grafitto, Woodward's building roof, September, 2002
Photo: Murray Bush CCAP photo

has likely seen the "worst block" in Vancouver shift once again, as intense police action in the Downtown Eastside has pushed much drug activity eastward along Hastings toward the 100 block East and even further to Oppenheimer Park. Yet many, if not most, of the buildings of the 100 block West, including Woodward's, remain empty and boarded up.

What has been largely absent from these conflicts is a recognition that the Downtown Eastside has not been overlooked by or resisted the transformation of downtown space. It is not a remnant of Vancouver's industrial past. Rather, as we have shown, it has long played a central role, both symbolically and materially, in the story of Vancouver. That which now characterizes the neighbourhood – the open drug market, the deepening poverty and desperation, the run-down streetscape – are products of the same forces which induced the proliferation of condo towers, art galleries, restaurants, cafés, nightclubs, townhouses, heritage neighbourhoods, and inner city middle class consumers. Zones of darkness and despair and the zone of happy prosperity are parts of the same city. The open drug market along Hastings Street appeared at precisely the same time that condos were being built in Gastown and in the other parts of the downtown peninsula. The sex trade shifted to East Vancouver at the same moment other inner city and downtown neighbourhoods were gentrifying. The storefront vacancy rate in the Downtown Eastside skyrocketed just as whole new residential and retail districts were being constructed in the downtown. Poverty intensified as housing prices began spiraling out of control.

To this point, debate has largely focused on what the city of affluence will do about and for the city of addiction and poverty. If both are products of the same sets of forces, is it possible to change one without changing the other? Is it possible to "improve" the neighbourhood without acknowledging the divide that slices across the social fabric of the city?

> ... the condo industry acts as if no one else is living in the neighbourhood,
> and they are homesteading an urban wilderness. . . . [T]his is already a
> vital community. It was made that way by residents, not by developers or
> others who patronize and insult poor people. Carnegie Centre, Crab Park,
> the network of decent and affordable social housing, improved safety in the
> hotels, the drugs driven out of Oppenheimer Park - these are the real signs
> of revitalisation.[57]

As David Ley points out, the term *revitalisation* is morally loaded, implying that those areas which revitalisation policies are directed toward are not currently vital.[58] Yet there are clearly those in the Downtown Eastside for whom the neighbourhood is vital.

Until such issues are addressed, there will be little peace in the Downtown Eastside. There has in fact been intensification – even militarization – of the rhetoric of confrontation. In 1998, poet Bud Osborn wrote a passionate defense of the Downtown Eastside against developers and displacement, declaring that:

> *we resist*
> *person by person*
> *square foot by square foot*
> *room by room*
> *building by building*
> *block by block*[59]

Four years later, City Councillor Jennifer Clark, having just been acclaimed the mayoralty candidate for the city's ruling Non Partisan Association, announced that "I will not be mayor of a city with a ghetto," and vowed to retake the Downtown Eastside "one block at a time."[60]

1. Alex Strachan, "High on Da Vinci: The Local Production Crew's Euphoric Mood Reflects the Feeling That This New CBC Drama Is Sure To Be a Winner," *Vancouver Sun* (July 6, 1998): B7.

2. Frances Bula, "A look at the worst block in Vancouver: 100 block West Hastings," *Vancouver Sun* (August 7, 1998): A1.

3. Walter McKay and Toby Hinton, "Skid road meets . . . Adam Smith," *Vancouver Sun* (Oct. 24, 1997): A21.

4. Kris Olds, "Mass Evictions in Vancouver: The Human Toll of Expo '86," *Canadian Housing*, 6 (1991): 49-52; Jeff Sommers, *The Place of the Poor: Poverty, Space and the Politics of Representation in Downtown Vancouver, 1950-1997*. Unpublished PhD dissertation (Simon Fraser University, 2001).

5. John Lowman, "Violence and the Outlaw Status of (Street) Prostitution in Canada," *Violence Against Women*, 6 (2000): 987-1011.

6. City of Vancouver, "Administrative Report 3504 To the Standing Committee on Planning and Environment on Panhandling" (1998): Mimeo.

7. *Vancouver Sun*, "Drugs are a cancer in the heart of the city." Editorial. *Vancouver Sun* (Oct. 17, 1998): A22.

8. Michael McCarthy, "Begging the question," *Vancouver Courier* (June 14, 1998): 1.

9. Quoted in Ian Bailey, "Guards ask panhandlers to move," *Vancouver Sun* (Dec. 22, 1997): B6.

10. Margaret Munro, "Vancouver's Raging HIV Epidemic Most Rampant in Developed World," *Vancouver Sun* (Oct 2, 1997): A1. If the population of Strathcona is included, it doubles to around 16,000.

11. McKay and Hinton, *op. cit.*

12. McKay and Hinton, *op. cit.*

13. Celia Sankar, "Down and Out in Vancouver: Potent Heroin is Killing Addicts Faster than the System Can Help Them," *The Globe and Mail* (July 20, 1998): A3.

14. McKay and Hinton, *op. cit.*

15. McKay and Hinton, *op. cit.*

16. Grant Longhurst (ed.), *The New Downtown: Where you live and work*, 2, 1 (1997). Given the significant differences between the two places, both contemporary and historical, one wonders whether the writer has ever actually been to Harlem. As Wacquant argues, places are not ghettos because they are poor, but rather poor because they are ghettos. Historically, places like Harlem contained quite prosperous, as well as poor and middle income, residents. They were, nevertheless, still ghettos. It is the intersection of continuing racial segregation and central city deindustrialization which has created the kinds of ghetto poverty now evident in the U.S. Loic J. D. Wacquant, "Three Pernicious Premises in the Study of the American Ghetto," *International Journal of Urban and Regional Research*, 21 (1997): 341-353.

17. Townsend, Ted, "Hotel Renovation Plan Brings Hope to Downtown Eastside." *Westender* (March 5, 1998): 3

18. Gastown Historical Area Planning Committee, Minutes of Meeting, September 25, 1996.

19. City of Vancouver, "Building Common Ground." In *The Downtown Eastside Revitalization Plan* (1998). Mimeo. Vancouver, BC.

20. R.A.J. McDonald, *Making Vancouver: Class, Status and Social Boundaries, 1863-1913.* (Vancouver: UBC Press, 1996).

21. A good introductory source on the social history of the area is *Labour, Work and Working People: Working Class and Labour History Walking Tour, Vancouver, BC,* available from the SFU Initiative for Labour Education and the Vancouver and District Labour Council.

22. City of Vancouver Archives, Pamphlets, 1938-112. Vancouver Housing Survey. Notes on the area bounded by Cordova, Main, Prior, and Gore. Greater Vancouver Youth Council.

23. Major Matthews, the City's first archivist, documents 13 different skid roads of this type in his Early Vancouver oral histories.

24. Baxter, Jamie, "City Limits: Time to Play," *Vancouver Sun* (April 3, 1997).

25. Murray Cromwell Morgan, *Skid Road: An Informal Portrait of Seattle* (1982). New York: Viking Press, 1982; Bill Casselman, *Casselman's Canadian Words : A Comic Browse through Words and Folk Sayings Invented by Canadians* (Toronto: Copp Clark, 1995). It is interesting to note that Vancouver and Seattle are the only two cities where the original term Skid Road held fast when it was deployed as a pejorative description of the lodging house district.

26. Rolf Knight, *Along the No. 20 Line: Reminisences of the Vancouver Waterfront,* (Vancouver: New Star Books 1980): 212-213.

27. Leonard Marsh, *Rebuilding a Neighbourhood: Report on a Demonstration Slum-Clearance and Urban Rehabilitation Project in a Key Central Area in Vancouver* (1950). The University of British Columbia: Vancouver, BC.

28. Bill Ryan, "Vancouver's Shame: Skid Road – Street of the Lost Souls," *Vancouver Province* (Nov. 8 – 13, 1952).

29. Ryan, *ibid.*

30. Cy Young, "Skidroad" (1951). Cited in A. Kloppenborg, *et al,* 1986, *Vancouver: A Pictorial History* (Vancouver: Douglas & McIntyre, 1986).

31. Art McKenzie, "Hastings St. Resolves to Halt the Skid," *Province* (June 18, 1966): 23.

32. *Vancouver Sun,* "Welcome to IDEAS Men." Editorial. *Vancouver Sun,* (June 28, 1966): 4.

33. City of Vancouver Planning Dept., *Downtown Vancouver, 1955-1976: City of Vancouver 20 Year Development Plan* (1956). Vancouver, BC.

34. Keith Bradbury and George Peloquin, "$275 Million Project Unveiled: Skyscraper-Studded Plan Mapped for the Waterfront." *Vancouver Sun* (June 28, 1966): 1

35. Thomas Cocking, "Moving Furniture Won't Help: It Can't Be Tidied Up So Easily." *Vancouver Sun* (Oct. 4, 1966). By "sex deviates" the author presumably means gays and lesbians.

36. Bud Elsie, "Vice and Drunkenness: Skid Road Cleanup Made City Target - Shocking Reports," *Vancouver Province* (May 14, 1965): 1

37. *Ibid.*

38. Glen Bohn, "Skid Road Cleans Up Its Act." *Vancouver Sun.* (March 14, 1984): A1.

39. David Ley, "The Downtown Eastside: 'One Hundred Years of Struggle'." In David Ley and Shlomo Hassan, *Neighbourhood Organizations and the Welfare State* (Toronto: University of Toronto Press, 1994).

40. Mark Hume, "Turned Out: They built Canada. Now they're uprooted." *Vancouver Sun* (March 8, 1986): A10.

41. Birmingham and Wood, *Restoration Report: A Case for Renewed Life in the Old City* (1969). Vancouver, BC.

42. *Ibid.*

43. *Ibid.*

44. Manfred Klenke, *Gastown Economic Study: 1966-1974* (1974). City of Vancouver Planning Dept.

45. Strachan, *op. cit.*

46. Heather Anne Smith, "Where Worlds Collide: Social Polarisation at the Community Level in Vancouver's Gastown/Downtown Eastside" (2000). PhD Dissertation. University of British Columbia: Vancouver, BC.

47. Figures from the 1971 and 1991 census calculated by the author. See Sommers, *op. cit.*

48. Bing Mar, in Birmingham and Wood, *op. cit.*

49. McKay and Hinton, *op. cit.*

50. Neil Smith, *The New Urban Frontier: Gentrification and the Revanchist City*, (New York: Routledge, 1996).

51. Robert Sarti, "Downtown Eastside: Housing Society Plans Secure Women's Residence in 'War Zone'." *Vancouver Sun* (March 27, 1995): B3.

52. Noel Hulsman, "Close Quarters," *BC Business* (November, 1998).

53. Woodward's Window Project: *Bringing Woodward's back to life . . . and back to the community*, undated flyer.

54. N. K. Blomley, "Landscapes of property," *Law and Society Review* 32, 3 (1998): 567-61.

55. Marg Green, quoted in Frances Bula, "Eastside groups vow to ensure Woodward's has social housing," *Vancouver Sun* (April 7, 1997): B3.

56. Neil Smith has recently argued that gentrification has become increasingly important to neo-liberal urban economic strategies, serving up 'the central and inner-city real estate markets as burgeoning sectors of *productive* capital investment' In 'New globalism, new urbanism: gentrification as global urban strategy' *Antipode*, 34, 3 (2002): 452-472. [*Ed. note: a significantly revised and amended version of Smith's* Antipode *article appears next.*]

57. A. Doinel, "The Incredible Shrinking Neighbourhood," *Carnegie Newsletter* (March 1, 1995). Mimeo: Vancouver, BC.

58. David Ley, *The New Middle Class and the Remaking of the Central City.* (Oxford, UK: Oxford University Press, 1996).

59. Bud Osborn, "Editorial: Raise Shit: Downtown Eastside Poems of Resistance," *Environment and Planning D: Society and Space*, 16, 3 (1998): 280-88.

60. Frances Bula, "Mayoral hopeful opens campaign," *Vancouver Sun* (June 2002): B3.

Vancouver, 1909, looking east from Dominion Trust Building
Bullen Photo Co., courtesy of the City of Vancouver Archives # P23 N243

G entrification today is still generally conceived in the way sociologist Ruth Glass defined the process four decades ago. Here is her founding 1964 statement that revealed gentrification as a discrete process:

> One by one, many of the working-class quarters of London have been invaded by the middle classes – upper and lower. Shabby, modest mews and cottages – two rooms up and two down – have been taken over, when their leases have expired, and have become elegant, expensive residences. Larger Victorian houses, downgraded in an earlier or recent period – which were used as lodging houses or were otherwise in multiple occupation – have been upgraded once again. . . . Once this process of 'gentrification' starts in a district it goes on rapidly until all or most of the original working class occupiers are displaced and the whole social character of the district is changed.[2]

Almost poetically, Ruth Glass captured the novelty of this new process whereby a new urban "gentry" transformed working-class quarters. But consider now an updated statement thirty-five years later, again from London. The following is an excerpt from the 1999 decree for "Urban Renaissance" released by a special Urban Task Force appointed by the UK Department of the Environment, Transport and the Regions:

> The Urban Task Force will identify causes of urban decline . . . and practical solutions to bring people back into our cities, towns and urban neighbourhoods. It will establish a new vision for urban regeneration. . . . [Over the next 25 years] 60% of new dwellings should be built on previously developed land . . . [W]e have lost control of our towns and cities, allowing them to become spoilt by poor design, economic dispersal and social polarisation. The beginning of the 21st century is a moment of change [offering] the opportunity for an urban renaissance.[3]

This language of urban renaissance is not new, of course, but here it takes on far greater significance. The scale of ambitions for urban rebuilding has expanded dramatically: whereas state-sponsored postwar urban renewal in western cities helped to encourage scattered private market gentrification, that gentrification and the intensified privatization of inner city land and housing markets since the 1980s has in turn provided the platform on which large scale multifaceted urban regeneration plans, far outstripping 1960s urban renewal, are established. The current language of urban regeneration, particularly in Europe, is not one-dimensional, but among other things it bespeaks a generalization of gentrification in the urban landscape.

Consider some key differences in the visions presented by Glass and the British Department of Environment. Whereas 1960s gentrification for Glass was a marginal oddity in the Islington housing market, a quaint urban sport of the hipper professional classes unafraid to rub shoulders with the unwashed masses, by the end of the century it had become a central goal of British urban policy. Whereas the key actors in Glass' story were assumed to be middle and upper-middle class immigrants to a neighbourhood, thirty-five years later the agents of urban regeneration were governmental, corporate, or corporate-governmental partnerships. A seemingly serendipitous, unplanned process that popped up in the postwar housing market is now, at one extreme, ambitiously and scrupulously planned. That which was utterly haphazard is increasingly systematized. In scale and diversity, the process of gentrification has evolved rapidly to the point where the narrowly residential rehabilitation projects that were so paradigmatic of the process in the 1960s and 1970s, themselves now seem quaint, not just in the urban landscape, but in the urban theory literature.

Most importantly, perhaps, a highly local reality, first identified in a few major advanced capitalist cities such as London, New York, Paris, and

Sydney, is now virtually global. Its evolution has been both vertical and lateral. On the one hand gentrification as a process has rapidly descended the urban hierarchy and is evident not only in the largest cities, but in more unlikely centres such as the previously industrial cities of Cleveland or Glasgow, smaller cities like Malmö or Grenada, and even small market towns such as Lancaster, Pennsylvania or Ceské Krumlov in the Czech Republic. On the other hand, the process has diffused geographically as well with reports of gentrification from Tokyo to Tenerife (Garcia 2001), São Paulo to Puebla, Mexico (Jones and Varley 1999), Cape Town (Garside 1993) to the Caribbean (Thomas 1991), Shanghai to Seoul, Vienna to Vancouver.

Of course, these experiences of gentrification are highly varied and unevenly distributed, much more diverse than early European or North American instances of gentrification. They spring from quite assorted local economies and cultural ensembles and connect in many complicated ways to wider national and global political economies. The important point here, however, is the rapidity of the evolution of an initially marginal urban process, first identified in the 1960s, and its ongoing transformation into a significant dimension of contemporary urbanism. Whether in its quaint form, represented by Glass' mews, or in its socially organized form in the twenty-first century, gentrification portends a displacement of working class residents from urban centres. Indeed, the class nature of the process, transparent in Glass' version of gentrification, is assiduously hidden in the verbiage of the British Labour government. That symptomatic silence says as much about the city's changing social and cultural geography, twinned with a changing economic geography, as does its more visible and voluble signs.

In the context of North America and Europe, it is possible to identify three waves of gentrification (Hackworth 2000). The first wave, beginning in the 1950s, can be thought of as "sporadic gentrification," much as Glass

observed it. A second wave of gentrification followed in the 1970s and
1980s as the process became increasingly entwined with wider processes
of urban and economic restructuring. From his research in New York City,
Jason Hackworth labels this the "anchoring phase" of gentrification. A third
wave of gentrification emerged in the 1990s, and we might think of this as
gentrification generalized. Of course, this evolution of gentrification has
occurred in markedly different ways in different cities and neighbourhoods
and according to different temporal rhythms. In Mexico City, for example,
the process is nowhere as highly capitalized or widespread as in New York,
remaining confined to the central district, in addition to Coyoacán, and the
demarcation of three identifiable waves of gentrification has little if any
empirical validity there. In Seoul or São Paulo, the process is geographically
isolated and in its infancy. In the Caribbean, the increasing connections
between gentrification and global capital generally filter through the
tourist industry, giving it its own distinct flavour. Likewise in Vancouver,
links between gentrification and global capital are tied to tourism and the
city's international image, but also to economic restructuring and official
governmental policies such as immigration and multiculturalism, all in
combination with a seeping neo-liberalism at every level of government.
By the same token, the transformation of mile after mile of old wharf
and warehouse properties along both banks of the Thames suggests that
gentrification in London is more expansive than in most North American
cities. Insofar as it is an expression of larger social, economic, and political
relations, gentrification in any particular city will express the particularities
of the place in the making of its urban space.

And yet to differing degrees, gentrification by the 1990s had evolved
into a crucial urban strategy for city governments in consort with private
capital in cities around the world. Liberal urban policy, which in Europe
dated back in some places to the end of the nineteenth century, and in

North America to the transition from the Progressive Era to Roosevelt's New Deal, was systematically defeated, beginning with the political economic crises of the 1970s and the conservative national administrations that followed in the 1980s. From Reagan to Thatcher and later Kohl and Mulroney, the provisions of that liberal urban policy were systematically disempowered or dismantled at the national scale, and public policy constraints on gentrification were replaced by subsidized private market transformation of the urban built environment. This transformation was intensified by the coterie of neo-liberal leaders that followed – Clinton, Blair, Schröeder, and Chretien – and the new phase of gentrification therefore dovetails with a larger class conquest not only of national power but of urban policy. By the end of the twentieth century, gentrification fueled by a concerted and systematic partnership of public planning with public and private capital, has moved into the vacuum left by the end of liberal urban policy. Elsewhere, where cities were not governed by liberal urban policy during much of the twentieth century, the trajectory of change has been different, yet the embrace of a broadly conceived gentrification of old centres as a competitive urban strategy in the global market leads in a similar direction. In this respect at least, turn-of-the-century neo-liberalism hints at a thread of convergence between urban experiences in the larger cities of what used to be called the First and the Third Worlds.

The generalization of gentrification has various dimensions, and these can be understood in terms of five interrelated characteristics: the transformed role of the state, penetration by global finance, changing levels of political opposition, geographical dispersal, and the sectoral generalization of gentrification. First, between the second and third waves of gentrification, the role of the state changed dramatically (Hackworth and Smith 2001). The relative withdrawal of the national state from subsidies to gentrification in the 1980s had in the 1990s been reversed with the

intensification of partnerships between private capital and the local state, resulting in larger, more expensive, and more symbolic developments, from Barcelona's waterfront to Berlin's Potsdammerplatz. Urban policy no longer aspires to guide or regulate the direction of economic growth so much as fit itself to the grooves already established by the market in search of the highest returns (either directly or in terms of tax receipts). Or, where there is the residual welfare state, as in Canada, policies cosmetically ameliorate housing conditions without essentially altering the market or the trajectory of gentrification.

The new role played by global capital is also definitive of the generalization of gentrification. From London's Canary Wharf to Battery Park City – developed by the same Canadian-based firm – it is easy to point to the new influx of global capital into large mega-developments in urban centres (Fainstein 1994). Vancouver's own mega-development of Concord Pacific Place on the north shore of False Creek is one of North America's largest redevelopment ventures, developed by a net of global capital that is densely trans-Pacific, emanating from Hong Kong billionaire Li Ka-shing (see Olds 1996). But, just as remarkable, however, is the extent to which global capital has percolated into much more modest neighbourhood developments. Emblematic in this regard is a new sixty-one-unit condominium building in New York's Lower East Side, two miles from Wall Street, where every apartment is wired with the latest high speed Internet connections, as are Vancouver's Concord Pacific Place apartments. This is small by global city standards, but it was built by non-union immigrant labour (a stunning development in New York in the 1990s), the developer is Israeli, and the major source of financing comes from the European American Bank (Smith and DiFilippis 1999). The reach of global capital down to the local neighbourhood scale is equally a hallmark of the latest phase of gentrification.

Concord Pacific Place, Vancouver, 2002

Photo: Reid Shier

Squatters' beds, Woodward's site development office, September 20, 2002
Photo: Reid Shier

Third, there is the question of opposition to gentrification. From Amsterdam to Sydney, Berlin to Vancouver, San Francisco to Paris, gentrification's second wave was matched by the rise of myriad homeless, squatting, housing, and other anti-gentrification movements and organizations that were often loosely linked around overlapping issues. These rarely came together as citywide movements, but they did challenge gentrification sufficiently that in each case they were targeted by city politicians and police forces. Apart from anything else, the heightened levels of repression aimed at anti-gentrification movements in the 1980s and 1990s testified to the increasing centrality of real-estate development in the new urban economy. Cities' political regimens were changing in unison with their economic profile, and the dismantling of liberal urban policy provided a political as much as economic opportunity for new regimes of urban power. The emergence of "the revanchist city" (Smith 1996) was not just a New York phenomenon, but can be seen in the anti-squatter campaigns in Amsterdam in the 1980s, attacks by Parisian police on homeless (largely immigrant) encampments, a police raid on a squatted eastside house in Vancouver in the late 1980s, and the importation of New York's zero tolerance techniques by police forces around the world. Or, as in Toronto, revanchist architectural details – such as minimal bus shelters with strategic serrated edges on the seating – take back public space from the homeless. In all of these cases, the new revanchism was explicitly justified in terms of making the city safe for gentrification. In Sao Paulō, highly repressive tactics applied to the city's street people are rationalized in terms of the "scientific" doctrine of "zero tolerance" emanating from New York. The new authoritarianism both quashes opposition and makes the streets safe for gentrification.

Vancouver Swat Team member during raid on Woodward's squat, morning of September 21, 2002
Still from video shot by Elisha Burrows, courtesy of the filmmaker and vancouver.indymedia.org

The fourth characteristic of this latest phase is the outward diffusion of gentrification from the urban centre. This is far from a smooth or regular process, but as gentrification near the centre results in higher land and housing prices, even for old, untransformed properties, districts further out become caught up in the momentum of gentrification. The pattern of diffusion is highly variable and is influenced by everything from architecture, parks, or the presence of water, but above all it is geared to the historical patterns of capital investment and disinvestment in the landscape. In B.C.'s Lower Mainland, gentrification has spilled over from Vancouver to the older city (and suburb) of New Westminster. Suffering under disinvestment and sputtering attempts at gentrification under the guise of urban renewal on its Fraser River waterfront downtown, the adjoining area of Queens Park, which was a mix of working, middle, and upper-middle classes, became homogenized as prices soared for Victorian houses on large garden lots. The waterfront Columbia Street area is a Hastings Street corollary bearing the residue of an initial gentrification that followed Expo '86. Yet a second small gentrification attempt is taking hold with a condo development in the former Post Office building. The condo dwellers, however, will be safe on this renewed urban frontier as the new Police Office is on the ground floor; the relationship of gentrification, security, and crime prevention – as well as the privatizing of governmental service (with the closure of the main Post Office) – is materialized on this one bleak corner. And as the working waterfront is increasingly deindustrialized – replaced with a clichéd B.C. teal and pink marketplace and casinos aboard Mississippi paddlewheeler boats – there is less chance to rub shoulders with the masses than there is to walk the empty street from the Army & Navy past the pawnshops to the lonely misplaced Starbucks. The more uneven the initial outward growth of capital investment and the more random the disinvestment in these newer landscapes, the less even will be the diffusion

of gentrification. New Westminster, tellingly, has both a gentrified area and an "extreme poverty tract" (Ley 1997) that has been generated, at one level, by the diffusion of the gentrification of Vancouver. By the same token, in cities where the majority of spatial expansion has occurred in recent years and where the opportunities for sustained disinvestment have been circumscribed, the diffusion of gentrification may be similarly limited. Vancouver contains both these patterns with the schematized disinvestment of the Downtown Eastside (much like the inner city pattern in the U.S.) and the diffusion of both gentrification and disinvestment to the suburban landscape.

Finally, the sectoral generalization that typifies this most recent phase goes to the heart of what distinguishes the new gentrification. Whereas urban renewal in the 1950s through the 1970s sought a full-scale remaking of the centres of many cities and galvanized many sectors of the urban economy in the process, it was highly regulated and economically and geographically limited by the fact that it was dependent on public financing and therefore was forced to address issues of broad social necessity, such as social housing. The earliest wave of gentrification that followed urban renewal proceeded, by contrast, with considerable independence from the public sector, yet despite large public subsidy the full weight of private-market finance was not applied until the third wave. The different rhythm of Vancouver and of the Canadian political economy does not produce as great an opportunity for such renewal, but regulations – particularly at the provincial level – are by no means stable. What marks the latest phase of gentrification in many cities, therefore, is that a new amalgam of corporate and state powers and practises has been forged in a much more ambitious effort to gentrify the city.

Retaking the city for the middle classes involves a lot more than simply providing gentrified housing. Third-wave gentrification has evolved into

a vehicle for transforming whole areas into new landscape complexes that pioneer a comprehensive class-inflected urban remake. These new landscape complexes now integrate housing with shopping, restaurants, cultural facilities (c.f. Vine 2001), open space, employment opportunities – whole new complexes of recreation, consumption, production, and pleasure, as well as residence. Capital and culture come together in this third wave of gentrification in a reinvigorated way that coincides with ideas of culture in globalization. Culture, in the form of artists' studio and galleries, is not so much the inevitable leading blade of the bulldozer (see Zukin 1982), but is a part of the new consumptive landscape, expanded from scattered galleries and studios to complexes, festivals, and signature museums. Like the role given culture in many globalization theories, culture at the urban level is merely part of an economic expansion – it is not imagined as something adding another texture to an area, to create a kind of cultural capital, no matter toward what ends, but it is yet another consumptive option. The global expansion of the Guggenheim Foundation – from the contested Basque zone of Spain, to Las Vegas, with designs on Brazil – epitomizes this cultural super-sizing. This shift to cultural consumption is a shift away from cultural production. Strikingly, in Vienna, a city which markets itself globally as a cultural city laden with history, excellence, and innovation, the new city centre cultural mega-project, The Museums Quartier, has dropped its studio residency program (production side) and will develop the space into a series of shops. Yet the role of culture, and cultural production, takes on different rhythms and roles within the various ways gentrification unfolds. In European cities as varied as Laibach and Gdansk, artists' groups are also oppositional to their city's transformation. A group of artists and activists, the Network or Action Committee for Metelkova, has effectively squatted a former military complex in Laibach in Slovenia for a decade, blocking the development of a shopping centre (see Grzinic

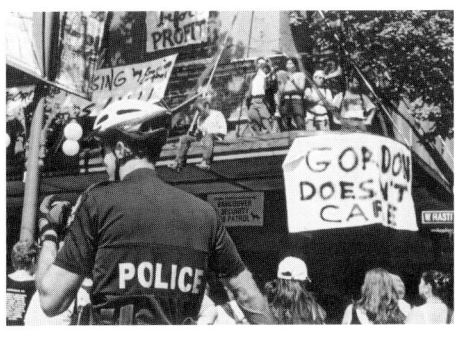

1999). In Vancouver, a city internationally known for its cultural production, artist-run centres have not greased the progress of gentrification in the same manner as galleries and artists' spaces and the ensuing "loft life" did in SoHo and the East Village in Manhattan – there are different urban rhythms of gentrification and various roles that both cultural production and cultural consumption play in particular cities. But, as the level of state funding withered, some artist-run centres in Vancouver uncritically turned toward public/private funding structures that led them to enter into arrangements with real-estate developers. These types of public sector-private sector arrangements now typify neo-liberal urban regeneration programs.

Just as important, gentrification as urban strategy weaves global financial markets together with large- and medium-sized real estate developers, local merchants, and property agents with brand name retailers, all lubricated by city and local governments for whom beneficent social outcomes are now assumed to derive from the market rather than from its regulation. Most crucially, real-estate development becomes a centrepiece of the city's *productive* economy, an end in itself, justified by appeals to jobs, taxes, and tourism. Just as Jimmy Carter's National Urban Program tied the revitalization of city economies to the national economy (see Smith 1996: 75-89), in Vancouver, the turn toward real estate and construction can be seen as a reaction to changes in the regional economy brought on by global economics. In the movements from resource exploitation to

Vancouver police officer directs traffic, Abbott and Hastings, September, 2002
Photo: Murray Bush CCAP photo

resource development and the expansion of non-manual jobs and then the long shift to an emphasis on "hospitality" and service industries with its restraints, cutbacks, layoffs, and union crushing – B.C.'s economy has been pressured from a number of angles, but most forcefully from globalization and the "world economy." After 1986, leftist critiques pointed out that "The global economy is changing, British Columbia is being left behind, and the government has no idea what to do about it" (Magnussen *et al*, 385). At the time, the profit-sniffing Social Credit government implemented a turn away from a productive industrial economy toward one centred on service industries, real estate, and construction (attacking the construction unions in the process and leading to the leaky condo scandal). In a sense, real estate and the urban territory were handled as yet another resource of "Super, Natural British Columbia" – exploited, managed, and shipped out. In some ways, real-estate development as a centrepiece of the city's *productive* economy could hardly have been envisaged in the 1960s, but the construction of new gentrification complexes in central cities across the world has become an increasingly unassailable capital accumulation

strategy for competing urban economies. Herein lies a central connection to the larger outline of a new urbanism, and we shall return to it presently.

The strategic appropriation and generalization of gentrification as a means of global inter-urban competition finds its most developed expression in the language of "urban regeneration." Consonant with the importance of the state in the new wave of urban change, it is not in the U.S. that this process has come furthest, but rather in

Banners on Woodward's "Eiffel Tower," September, 2002
Photo: Murray Bush CCAP photo

Europe. Tony Blair's Labour administration may be the most outspoken advocate of reinventing gentrification as "urban regeneration," but it is a Europe-wide movement. Denmark, for example, made regeneration official policy in 1997, with a separate "National Secretariat for Urban Regeneration" (recently disbanded by the right wing government), and Berlin bureaucrats have come to view the entire period of rebuilding after 1991 as one of "urban regeneration." A major conference was held in Paris in December 2000 on the theme: "Convergence in Urban Regeneration and Housing Policy in Europe." Attended by senior policy directors and advisors representing all governments of the European Union, together with some neighbouring states aspiring to EU membership, the conference tried to push the "debate on housing and regeneration beyond the narrow span of physical development to examine the institutional arrangements which have to be put into place" in order to make "urban regeneration" a reality. Their mission was practical and comprehensive: large-scale urban transformation will require solid links between "the providers of social housing, private investors, [and] those responsible for training or policing" as well as between "local regeneration agencies, local authorities and national governments." Regeneration policies are multifaceted and include various efforts that would not normally be included under the label, "gentrification," yet it also makes sense to see these initiatives – the British urban regeneration manifesto, European state policies, and the efforts to establish a Europe-wide urban regeneration strategy – as at the same time the most ambitious attempts to incorporate gentrification at the heart of transnational urban policies.

There are a number of striking aspects to these new "urban regeneration" agendas. First is a question of scale. The co-ordination of urban "regeneration" strategies across national boundaries is unprecedented. While various international sources certainly contributed

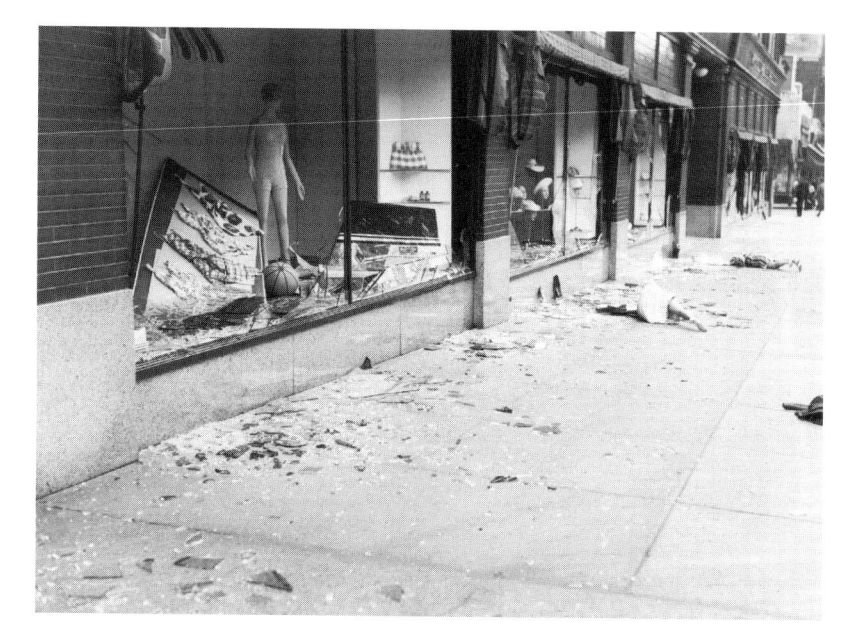

Broken windows of Woodward's department store after Post Office and Art Gallery sit-down strike, 1938
Courtesy of Pac Press and Vancouver Public Library Special Collections # 1305

to the rebuilding of European cities after World War II, the subsequent urban renewal programs were resolutely national in origin, funding, and scope. Today, by contrast, Europe-wide initiatives on urban regeneration are pioneering cross-national gentrification at a scale never before seen. A central concern lies with efforts to integrate housing initiatives with "other regenerative activities," and so as the title of the Paris conference conveys – "Convergence in Urban Regeneration and Housing Policy in Europe" – this transition from housing-centred gentrification policy to a broad-based multi-sectoral "regeneration" is still in process; unlike in the United States, the question of social housing cannot be entirely excluded from the vision of regeneration. While a Europe-wide state-centred strategy of urban regeneration is by no means yet in place, for Eureaucrats, developers, and financiers throughout the continent, it is very much in sight. A crucial connection to the earlier discussion of the new urbanism becomes clear: third-wave gentrification is increasingly expressive of the rescaling of the urban *vis-à-vis* national and global scales.

Alongside this European strategy, a Canadian policy is in the remaking. Following pressure from Jane Jacobs, along with mayors of the major cities and the Federation of Canadian Municipalities, the Federal Government is moving toward a scale of intervention that has historically been left in the hands of the provinces. The Privy Council Office has formed the most Canadian of research forms, a Task Force, on "urban communities" and urban affairs to be completed by fall 2002 (Winsor 2002). But the federal government has had a shaping hand in Canadian social geography and urban territory by other policies: immigration, multiculturalism, and housing programs. Shifts in the unabashedly instrumental immigration policies, particularly since the late eighties, have reshaped the major cities. In a sense, Canadian immigration policies have themselves migrated from a rural emphasis to an urban effect: first to bring settlers to "people" the

land and colonize it through agriculture, to the post-wwII emphasis on industrial and construction workers, to a more flexible and liberal "points system," and to the post-eighties policies that dramatically increased the number of immigrants, privileging those with financial capital, investment, and business experience (Mitchell 1996). These new economic immigrants have settled overwhelmingly in cities, particularly Vancouver, Toronto, and Montreal, adding to the "multicultural" urban area, and altering the class make-up of the cities (see Ley and Tutchener 1999).

A corresponding shift, then, is toward a much larger proportion of "non-European" immigrants than those from Europe and America. Multiculturalism, first adopted by Canada in the early seventies and introduced as official policy in 1988, has both a cultural and an economic basis, but it also has spatial effects in cities. As Katharyne Mitchell (1993) has written, multiculturalism is tied to the entry of global capital into Canada, capital which then reshapes the urban landscape. In a blending of capital and culture, the tolerant image of a multicultural Vancouver had a role in attracting Li Ka-shing and his son Victor to buy the north shore of False Creek. Multiculturalism is part of "the socially constructed nature of property investment and development process."[4] Coincidental to the introduction of multiculturalism, although related only as a Trudeau-era government policy, the National Housing Act established co-operative housing which developed this alternative housing form in the most stressed areas of cities (Ley 1993). But by 1993, aping neo-conservative and Thatcherite attacks on social programs, the federal government cut funding for new social housing. In its place, and in a language echoing "regeneration," there is the Residential Rehabilitation Assistance Program (RRAP) which provides grants for "upgrades" and maintenance of existing buildings.

Second, in urban regeneration plans, is the question of geographical focus. The 1999 British regeneration manifesto, apparently watchful of

the environmental consequences of continued suburban sprawl, declared that over the next twenty-five years, sixty percent of new housing provision should occur on "brownfield" sites, that is, on urban land that has already gone through one or more cycles of development. Clearly this initiative is aimed at older urban areas that have undergone sustained disinvestment, and while these can be scattered throughout metropolitan areas, it is reasonable to expect that they would be concentrated in or near urban centres: enveloped as regeneration, gentrification is recast as a positive and necessary environmental strategy. Connected, therefore, is the question of "social balance" and the need, as the regeneration strategy puts it, to "bring people back into our cities." "Social balance" sounds like a good thing – who could be against social balance? – until one examines the neighbourhoods targeted for "regeneration," whereupon it becomes clear that the strategy involves a major colonization by the middle and upper-middle classes. To the politician, planner, or economist, social balance in London's Brixton means bringing "back" more of the white middle classes. Advocates of "social balance" rarely if ever advocate that white neighbourhoods should be balanced by equal numbers of people of African, Caribbean, or Asian descent. Thus it is not "people" in general who are to be brought "back into our cities" – this appeal is not aimed at Welsh coal miners, Bavarian farm workers, Bretton fisher folk – rather, the appeal to bring people back into the city is always a self-interested appeal that the white middle and upper-middle classes retake control of the political and cultural economies as well as the geography of the largest cities. Probing the symptomatic silence of who is to be invited back into the city begins to reveal the class politics involved.

Then there is the question of the anodyne language of "regeneration" itself. In the first place where does this language come from? A bio-medical or ecological term, "regeneration" applies to individual plants, species,

Unemployed protest march at the corner of Hastings and Cambie (ca 1930s)

Courtesy of Vancouver Public Library Special Collections # 8813

or organs – a liver or a forest might regenerate – and insinuates that the strategic gentrification of the city is actually a natural process. Thus the advocacy of regeneration strategies disguises the quintessentially social origins and goals of urban change and erases the politics of winners and losers out of which such policies emerge. Gentrification generally involves displacement, yet neither the British manifesto for "urban regeneration" nor the agenda of the Europe-wide conference registers any recognition of the fate of those people displaced by the proposed reconquest of the city.

The language of regeneration sugarcoats gentrification. Precisely because the language of gentrification tells the truth about the class shift involved in "regeneration" of the city, it has become a dirty word to developers, politicians, and financiers, and we find ourselves in the ironic position that in the United States, where the ideology of classlessness is so prevalent, the language of gentrification is quite generalized, whereas in Europe it is suppressed. Thus even seemingly progressive planners and local councillors from Bochum to Brixton, who still think of themselves as socialists and who may be keenly aware of the dangers of displacement, have become captured by the bureaucratic promise of "regeneration" to such an extent that the integral agenda of widespread gentrification of urban centres is largely invisible. Not only does "urban regeneration" represent the next wave of gentrification, planned and financed on an unprecedented scale, but the victory of this language to anaesthetize our critical understanding of gentrification in Europe represents a considerable ideological victory for neo-liberal visions of the city.

If in Canada there is a language of urban rehabilitation at the national level, at the provincial level, the B.C. Housing program displays a deepening of neo-liberal policies and turns very directly toward a language of both redevelopment and rehabilitation. Once the class aspect of redevelopment is understood, gentrification and redevelopment cannot be separated –

"Tent City," squatters' camp, Woodward's building, November, 2002
Photo: Reid Shier

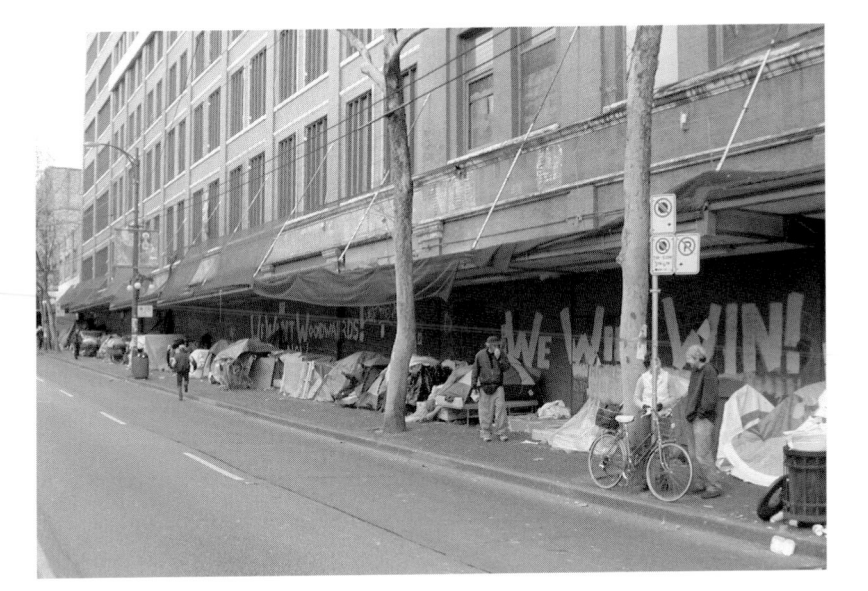

"Tent City," squatters' camp, Woodward's building, November, 2002

Photo: Reid Shier

so a language of redevelopment also anaesthetizes an understanding of gentrification. Indeed, the language of B.C. Housing follows the neo-liberal tactic of presenting its policies as the only solution and obscuring alternative or even existing approaches. So, the opening statement of the annual reports, "B.C. Housing, together with our partners, is working to address growing and changing housing needs in an environment where resources are diminishing and cost increasing," leads to the declaration that "Traditional responses to funding, capital, and direct service delivery are no longer sustainable."[5] This integral agenda of decreasing funding and services is presented as if there are no agents or alternatives. Constrained by the "availability of funding," redevelopment and "regeneration" "require effective and integrative partnerships with tenants, community organizations, and the private sector to support those individuals with more complex housing needs." This vague plan to redevelop existing public housing stock echoes the European state-centred regeneration strategy. And like Europe, the state functions not so much as a provider of public housing, but as the facilitator of the redevelopment "partnerships" of the various groups and developers on whom social housing will be either off-loaded, or offered for potential profit.

The City of Vancouver has initiated a Downtown Eastside Revitalization Program, for this "community rich in history, architecture and diverse groups of people," and its goal is to "provide a healthy, safe, and livable neighbourhood for all." Unlike the provincial program, and unlike the British manifesto for regeneration, the city program addresses displacement of people living in the Downtown Eastside. Despite an increase of fifty-one percent in housing units (almost 4,800 units) from 1991 to 1996, including "historic condo development," there has been a loss of 242 Single Room Occupancy dwellings (SROS) between 1991 and 1996. SROS are the small, usually ill-maintained rooms in older hotels and rooming houses for which,

despite the relatively low level of rent, occupants generally pay more than sixty percent of their income. And from 1970 to 1997, sros in this area decreased by 6,300 rooms (due to redevelopment, City closures, and fire), while only 4,000 new social housing units filled the widening gap. Given the decline in the number of sros and the slowing pace of their replacement by other affordable units, we can ask whether the city's revitalization really does, as claimed, create a "livable city for all." Given the pressures on Vancouver generated by decades-long low vacancy rates and high housing costs, sustained social disinvestment in the Downtown Eastside, the larger restructuring of space fuelled by the shifting class make up of the city, as well as the expectations of global capital and the dramatic emphasis on the urban built environment as a productive capital investment (partially displacing an industrial economy), all the elements for intensified gentrification and transformation, as global urban strategy, are abundantly in place. Given, as well, the institutionalization of neo-liberal and revanchist policies by the current Liberal government, and the emerging recession, gentrification will likely intensify across Vancouver and radically transform the Downtown Eastside. This gentrification will represent the struggle to retake this area of the city for the middle class, spearheading a class-inflected remake of the Downtown Eastside. Yet as the recent squatting of the Woodward's building has shown, this gentrification will not slide by obscured in its organic "regeneration" metaphor or in its sugar-coated classless language. Instead, a building that was an important part of the urban experience of Vancouver for generations – which has sat unused and speculated upon for nearly a decade – will likely continue to be the site of opposition and revanchist repression. Will the Woodward's building become the Tompkins Square Park of Vancouver? Symbolically and materially it could well be. At the very least it stands as a flash point generated by the centrality of real-estate development in the new urban economy.

The point here is not to force a one-to-one mapping between regeneration and gentrification strategies, nor to condemn all regeneration strategies as Trojan horses for gentrification. Rather, we want to insist that gentrification is a powerful if often camouflaged intent within urban regeneration strategies, and a critical challenge must be mounted against the ideological anodyne that sweeps the question of gentrification from sight even as the scale of the process becomes more threatening and the absorption of gentrification into a wider neo-liberal urbanism becomes more palpable. Gentrification as global urban strategy is a consummate expression of neo-liberal urbanism. It mobilizes individual property claims via a market lubricated by state donations.

Conclusion

Gentrification has evolved as a competitive urban strategy within the global economy. The post-1990s generalization of gentrification as a global urban strategy plays a pivotal role in neo-liberal urbanism in two ways. First, it fills the vacuum left by the abandonment of twentieth-century liberal urban policy. Second, the generalization of gentrification serves up the central and inner city real-estate markets as burgeoning sectors of *productive* capital investment: the globalization of productive capital embraces gentrification. This was neither inevitable nor accidental: rather, as cities became global, so did some of their defining features. The emerging globalization of gentrification, like that of cities themselves, represents the victory of certain economic and social interests over others, a reassertion of (neo-liberal) economic assumptions over the trajectory of gentrification.

Even where gentrification *per se* remains limited, the mobilization of urban real estate markets as vehicles of capital accumulation is ubiquitous,

and can be registered dramatically in Vancouver in the last decades. A
further symptom of the intense integration of the real-estate industry into
the definitional core of neo-liberal urbanism comes from such other cities
as Kuala Lumpur, Singapore, Rio de Janeiro, and Mumbai, where real estate
prices in the 1990s have multiplied manyfold. The same processes of capital
centralization that accentuate the contradiction between production and
social reproduction also enhance the gentrification process, although of
course this works out in very different ways in different places. In Mumbai
especially, market deregulation and global competition in the mid-1990s led
to "extravagantly high prices" that briefly eclipsed even New York, London,
and Tokyo.[6] Highly volatile, the extremes of 1996 have receded, but the
upper end of the Mumbai real-estate market now forever finds itself in
competition with real estate in cities across the world, a condition which has
brought small scale but very real gentrification to some neighbourhoods.

Whereas the major territorial axis of economic competition prior to
the 1970s pitted regional and national economies against each other, by
the 1990s the new geographical axis of competition pitted cities against
cities in the global economy. This competition takes place not simply in
terms of attracting and keeping industrial production, but in marketing
cities as residential and tourist destinations. This was explicit in British
regeneration policies, such
as City Challenge in the
1990s (Jones and Ward),
and equally explicit from
New York to Atlanta to
Vancouver where anti-
homeless policies were
justified in terms of an
enhanced tourist industry.

TV and lights, Woodward's building, September 20, 2002
Photo: Reid Shier

Travel and Leisure magazine now hosts a regular feature that appropriates the language of "emerging economies" to put a spotlight on "emerging cities." Montevideo is renowned for its "thriving café society"; Tunis "has a grandeur that calls to mind Prague and Vienna"; "Panama City is fashioning itself as the culturally savvy gateway" to the Canal Zone: "once you've settled in, get out and shop;" and "Cracow is experiencing a renaissance."[7] Similar aspirations scripted Rudy Giuliani's response after the World Trade Center catastrophe: "Go out and lead a normal life," he exhorted three days after September 11th. "Go to restaurants, go to plays and hotels, spend money."

Henri Lefebvre once argued that urbanism had supplanted industrialization as the motive force of capitalist expansion: industrialization may have bred systemic urbanization, but it was now urbanization that engendered industrialization (Lefebvre 1971). That claim has not withstood the test of time, especially in light of the globalization of industrial production and the expansion of East Asia that was well in tow as Lefebvre wrote; and yet he seems to have anticipated something very real. In a global sense urbanization has not, of course, supplanted industrialization; all of the products that fuel urbanization are made somewhere in the global economy. Still urban real-estate development – gentrification writ large – has now become a central motive force of urban economic expansion, a pivotal sector in the new urban economies. An adequate theoretical understanding of neo-liberal urbanism will have to revisit Lefebvre's argument and discern its insights from its exaggerations.

1. This essay is a significantly revised and amended version of a piece originally published as "New Globalism, New Urbanism: Gentrification as Global Urban Strategy" in *Antipode*, Volume 36.

2. Ruth Glass, *London: Aspects of Change* (Centre for Urban Studies and MacGibbon and Kee, 1964), xviii.

3. UK Department of the Environment. *Towards an Urban Renaissance* (London: UNDETR, 1999).

4. Kevin Olds. "Developing the Trans-Pacific Property Market: Tales of Vancouver via Hong Kong." Vancouver: Research on Immigration and Integration in the Metropolis (RIIM), Working Paper Series 96-02, 1996, 15.

5. B.C. Housing Annual Report (2001-2002).

6. J. Nijman. "Mumbai's Real Estate Market in the 1990s: De-regulation, Global Money and Casino Capitalism." *Economic and Political Weekly*, February, 2000, 12: 575.

7. Travel and Leisure January 2000, 50.

Works Cited

City of Vancouver. "Downtown Eastside Revitalization Program." *city.vancouver.bc.ca/commsvcs/ planning/dtes/dtehome.htm*

Fainstein, S. *City Builders. Property, Politics and Planning in London and New York.* Oxford: Basil Blackwell, 1994.

Garcia, L. M. "Gentrification in Tenerife." Paper presented to the ISA Group 21 Conference, Amsterdam, June, 2001.

Garside, J. "Inner-city Gentrification in South Africa: the case of Woodstock, Cape Town." *GeoJournal* 30: 29-35, 1993.

Glass, R. *London: Aspects of Change.* London: Centre for Urban Studies and MacGibbon and Kee, 1964.

Government of British Columbia. BC Housing Annual Report 2001-2002. *www. gov.bc.ca*

Grzinic, Marina. "Aktion in Zonen der Indifferenz," *Kursiv* 6: 48-60, 1999.

Hackworth, J. "The Third Wave." PHD dissertation, Rutgers University, 2000.

Hackworth, J. and Neil Smith. "The State of Gentrification." *Tijdschrift voor Economische en Sociale Geografie* 92, 2001.

Hiebert, Daniel. "The Social Geography of Immigration and Urbanization in Canada: A Review and Interpretation." Metropolis: Vancouver Centre of Excellence. Working Paper Series #00-12.

Jones, G. and A. Varley. The Reconquest of the Historic Centre: Urban Conservation and Gentrification in Puebla, Mexico. *Environment and Planning* A 31: 1547-1566, 1999.

Lefebvre, Henri. *La Révolution Urbaine.* Paris, 1971.

Ley, David. "Co-operative Housing as a Moral Landscape: Re-Examining The 'Post-Modern City'." *Place/Culture/Representation.* Eds. James Duncan and David Ley. London/New York: Routledge: 128-148, 1993.

_____ and Heather Smith. "Is There an Immigrant 'Underclass' in Canadian Cities?" Metropolis: Vancouver Centre of Excellence. Working Paper Series #97-08. *riim.metropolis.net*

_____ and Judith Tutchener. "Immigration and Metropolitan House Prices in Canada." Metropolis: Vancouver Centre of Excellence. Working Paper Series #99-09. *riim.metropolis.net*

Maguson, Warren *et al. After Bennett: a new politics for British Columbia*. Vancouver: New Star, 1986.

Mitchell, Katharyne. "Multiculturalism, or the United Colors of Capitalism?" *Antipode* 25(4): 263-294, 1993.

Mitchell, Katharyne. "Visions of Vancouver: Ideology, Democracy and the Future of Urban Development." *Urban Geography* 17(6): 478-501, 1996.

Nijman, J. "Mumbai's Real Estate Market in the 1990s: De-regulation, Global Money and Casino Capitalism." *Economic and Political Weekly* February 12: 575-82, 2000.

Olds, Kevin. "Developing the Trans-Pacific Property Market: Tales of Vancouver via Hong Kong." Vancouver: Research on Immigration and Integration in the Metropolis (RIIM), Working Paper Series 96-02, 1996. *riim.metropolis.net*

Smith, N. *New Urban Frontier: Gentrification and the Revanchist City*. London: Routledge, 1996.

Smith, N. and J. DiFilippis. "The Reassertion of Economics: 1990s Gentrification in the Lower East Side." *International Journal of Urban and Regional Research* 23, 1999: 638-653, 1999.

Thomas, G. "The Gentrification of Paradise: St. John's, Antigua." *Urban Geography* 12: 469-87, 1991.

UKDETR (UK Department of the Environment). "Towards an Urban Renaissance." *regeneration. detr.gov.uk/utf/renais/1.html*, 1999.

Vine, David. "Development or Displacement? The Brooklyn Academy of Music and Gentrification in Fort Greene." Paper presented at Gotham History Festival, New York, October 2001.

Winsor, Hugh. "Liberals Unroll Red Carpet for Urban Issues." *globeandmail.com*, August 14, 2002.

Zukin, Sharon (1982) *Loft Living*. Baltimore: Johns Hopkins University Press, 1982.

Stan Douglas, *The Downtown Eastside* (2002), C-Print (66 cm x 116 cm)
Courtesy of the artist and David Zwirner, New York

HAUNTED SPACES *Denise Blake Oleksijczuk*

*"There ought to be topographers who would give us an exact
account of the places where they have been."*

M. Montaigne, *Of Cannibals*[1]

S tan Douglas' *Every Building on 100 West Hastings* is a large, nocturnal panorama of a colourful and continuous row of old wood and brick buildings in Vancouver's Downtown Eastside.[2] It lies one block west of Carrall Street, the north-south axis of the city's 100 block grid system, and the historic centre of the city.[3] Even for spectators unaware that for decades Hastings Street was the most important social and commercial thoroughfare in Vancouver, this picture tells a story of tragic decline. The city block, a fundamental unit that organizes and shapes the space of the city and the lives of its inhabitants, provides a context in which social rules and expectations are internalized.[4] Attempts to isolate people with low incomes, sex trade workers, and drug users within a bounded space such as the Downtown Eastside is an important means through which power is produced and maintained in the city. Douglas' picture therefore represents a location that is at the same time marginal and central. *Every Building on 100 West Hastings* is a work that resists viewers' attempts to incorporate only ideal images of the city. The luminous, expansive photograph, rich in colour and texture, allows observers a chance to reconsider their relationship to this space and, by extension, to the socially undervalued. It engages spectators in an active rather than passive form of looking, which may, in turn, also involve us in a process of idealization crucial to the act of identifying with others.[5]

In his essay on the work of art historian Louis Marin, Roger Chartier theorizes that the power of the image lies in its double function.[6] Images at once make the absent, or the dead, present to the viewer, and they constitute the spectator as a subject engaged in the act of looking.[7] Douglas' panoramic print performs both of these functions, but it does so in a manner that both points to and produces a sense of absence itself. The picture's profound emptiness is one of the organizing principles that might be used to unite the subject matter of the picture, this particular block of Hastings Street

at night; its multi-perspectival visual format which encourages fleeting, embodied readings; and an ongoing, highly publicized social crisis in the Downtown Eastside.

While images function as reservoirs of signs that lend themselves to an indefinite plurality of meanings,[8] they function as sites of negotiation between the different groups or individuals who use them to affirm their identity. Chartier reminds us that "the structures determining relationships between individuals need to be understood as the result of continually conflictive and antagonistic representations of the social world."[9] Thus images and the interpretations that are made of them are thoroughly bound up with social conflicts. For instance, one of the prominent aspects of Douglas' representation of the 100 block West Hastings is that this usually busy street is desolate. This particular way of presenting the street can be understood as an allusion to not only the violence and neglect that caused its precipitous decline – the no trespassing signs on the six boarded-up buildings at the middle of the block are indications of the contempt that property owners have for the poor and homeless – but also to the tragic situation that has recently brought so much attention to the area.

Every Building on 100 West Hastings was produced and is being exhibited during with the most notorious case of social and civic neglect in the city's history: the disappearance of sixty-three women from the Downtown Eastside. This horror story is the main narrative I bring to Douglas' picture. Vancouver Police first announced in 1998 that a number of women had vanished from the neighbourhood. In 1999, they produced a poster of the missing women. At that time the total was thirty-one. Although it has now climbed to sixty-three, many believe that the number missing is much higher.[10] Because most of the missing are sex trade workers and drug users, evidence suggesting a serial killer was responsible was not rigorously pursued until a series of explosive articles by Lindsay

Kines and Kim Bolan in *The Vancouver Sun* were published in September
of 2001. In response to the public pressure that resulted from the articles,
a high profile task force was struck which eventually led to a murder
investigation in February 2002, after personal items and body fragments
(identified by DNA samples) of several of the missing women were found on
the accused killer's farm in Port Coquitlam.

The representational acts of combining these women's names on a
list, and of bringing together their portraits on a poster and in the pages
of the local newspaper, led to the formation of the Missing Women's Task
Force. Only when the number of women disappearing from the Downtown
Eastside began to be counted, when they ceased to be a problem concerning
individuals and began to be seen as a pattern affecting an entire community,
did their disappearances become important enough to warrant media
publicity, and to inspire widespread alarm and shame. My purpose in
referring to this crisis is to conjure up a metaphorical neighbourhood, one
where the Downtown Eastside's dead and missing women are woven into
the deceptively articulate and transparent image of Douglas' composite and
impenetrable urban block.

A picture of this block at this time, then, has the potential to indicate
that a space of tragedy, and its long-term dismissal by those at a safe
distance from it, lies at the core of Vancouver's social and psychic life.
An unavoidable conclusion must be that the disappearances of these
women were not only tolerated by but characteristic of a society that
dehumanized them because of their status as prostitutes and drug users.
Feminist psychoanalytic theorist Kaja Silverman proposes that one way
of transforming our relations with the socially disprized is through the
productive use of visual images. Explaining that love is inextricably bound
up with the psychic activity of idealization, she contends that aesthetic
images have the potential to re-educate our look, to reconfigure our notions

of the ideal, and put us into an identificatory relation to despised bodies.[11] She writes that, "We need aesthetic works which will make it possible for us to idealize, and, so, to identify with bodies we would otherwise repudiate."[12] Such works resist our attempts to assimilate the sanctioned images of the mass media, and would involve us in an active form of idealization. Within this frame, dominant representations of the Downtown Eastside continually warn us to stay away, to avoid this part of the city because the people who live and work there either are not like "us" or pose a threat to the privileged social body.[13] In contrast, alternative, aesthetic images like Douglas' panorama may encourage spectators to cross both social and psychic boundaries not simply to feel empathy by putting themselves in these women's shoes, but to consciously and corporally implicate themselves in that which is disavowed.

INVERSIONS

To some extent, Douglas' work quotes *Every Building on the Sunset Strip*, an accordion-fold artist's book made in 1966 by Los Angeles-based artist Ed Ruscha. But Douglas not only quotes this work, he inverts its schema in

ways that predispose his picture to the exploration of social conflicts. Douglas imitates the Duchampian treatment Ruscha used to frame the Sunset Strip,

Ed Ruscha, *Every Building on the Sunset Strip* [detail of accordion fold book] (1966)
Courtesy of the artist, collection of Claudia Beck and Andrew Gruft; photo: Milutin Gubash

without any obvious artistic alterations or commentary. He also imitates
the way Ruscha counters familiar images of the Strip with his dead-pan
representation of it. In Ruscha's work there is a clear contrast between
his inexpensive and mass produced booklet and the glamour, wealth,
and beauty associated with West Hollywood's decadent main drag. Since
prohibition times, the Sunset Strip has been a nocturnal mecca for people
in pursuit of the pleasures offered by its elite supper clubs such as the
Trocadero, Mocambo, and Ciro's, its rock music bars like the Whiskey A-Go-
Go, its strip clubs, and its twenty-four-hour diners. Contrasting its exciting
image, Ruscha's daytime photographic composition – displaying each and
every building and structure on the mile and a half stretch from Crescent
Heights to Doheny – makes the street look banal. The modest black and
white snapshots, strung together in two parallel strips showing both sides
of the street from the centre, sap the Strip of its glamour and mystique by
including ordinary people walking and driving on it during the day.

Choosing instead to depict the poorest neighbourhood in the country,
Douglas has chosen a different visual format to portray a block in his own
city, where he rented studio space during the 1990s. His deluxe, sixteen-
foot, digitally manipulated photo-print is expensive, meticulously rendered,
and framed to hang on a gallery wall. Where Ruscha left disjointed seams
between each photograph along the long strip, Douglas uses the latest
computer digital technology to fashion an all-encompassing image of a
solitary block with one carefully joined seam in the middle. By comparison
with Ruscha's ephemeral and ostensibly artless representation of one of
America's richest and most illustrious streets during the day, Douglas' work
offers a refined and visually stunning picture of Vancouver's most shunned
and disparaged area at night. Hence, although Douglas quotes Ruscha's
treatment of the Sunset Strip, he inverts its design. This inversion is not
simply a question of substituting day for night, black and white for colour,

famous for infamous urban street, or small-scale, simply made, inexpensive booklet for a large-scale, high tech, costly photo-print. More significantly, whereas Ruscha's work undermines the vitality and historical resonance of this famous American boulevard, Douglas' work documents a street in its death throes. Ruscha's piece is about ordinary, everyday life. Douglas' work is about death: not simply the death of a retail zone and the subsequent disappearance of regular customers, but the increasing numbers of human deaths in the area caused by drug overdoses, HIV/AIDS, and murder. The photograph displays an uninterrupted row of Edwardian façades. A few stores and facilities on the block have their iron bars drawn for the night, but most are closed permanently, with boards covering their windows and doors. Many are for sale. The types of establishments that remain are the kind one finds in distressed neighbourhoods: pawnshops advertising cash for CDs, tapes, stereos; a Salvation Army emergency shelter; and two small rooming hotels, The Argyll and The Crown, which serve long-term tenants and sex trade workers alike.

Dominant textual and visual representations of the city tend to overlook this area. In fact, recently published guidebooks to the city specifically warn readers to avoid Hastings Street in particular, especially at night.[14] Douglas' dark depiction of a street that was once the daytime commercial centre of Vancouver counters such representations by showing us the material and social consequences of such neglect.[15] If, as some have argued, history is a conversation with the dead, this picture may indirectly function as a document that allows spectators to engage in such an exchange.

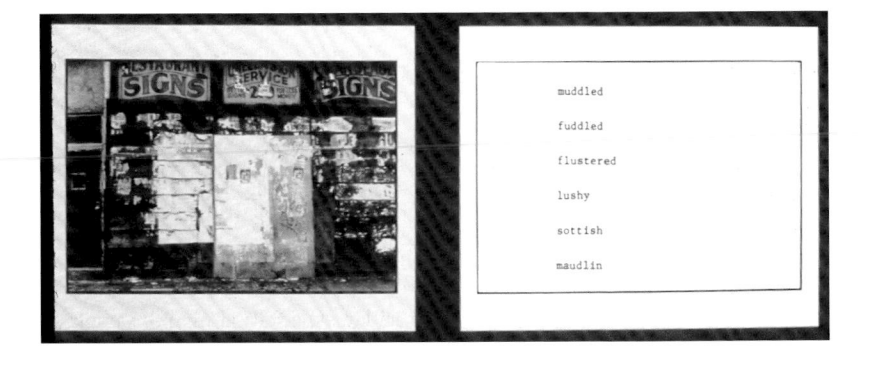

Martha Rosler, *The Bowery in two inadequate descriptive systems* [detail] (1974-5), one of 45 pairs, 8 in x 10 in each

Courtesy of the artist and Gorney Bravin + Lee, New York

DOCUMENTARY PHOTOGRAPHY

Douglas' composition involves spectators in an embodied viewing process that incites the search for an absence, both in the picture and in the experience of viewing. In depicting a highly contested location in the city, *Every Building on 100 West Hastings*, to a much greater extent than Ruscha's *Every Building on the Sunset Strip*, is embedded in a set of issues and debates concerning documentary photography. Strong parallels, as well as divergences, can be found between Douglas' piece and Martha Rosler's *The Bowery in two inadequate descriptive systems* (1974 – 75). Rosler's images of the Bowery are tightly focussed black and white snapshots of the small, shopfront spaces that alcoholics inhabit after business hours. Taken during the day, the photographs do not depict the dispossessed themselves but rather evoke the material conditions of their lives. Rosler accompanies her photographs with lists of slang used to describe drunkenness, such as stewed, boiled, pickled, preserved, and fried to the hat. Together, the images and texts point to an unrepresentable human misery.

In *not* representing the poor and indigent, Rosler refuses to allow viewers the easy satisfaction of feeling pity, or worse, of being comforted by the fact that they themselves are much better off. By depicting only empty spaces and old-fashioned terms for drunkenness, she shifts the focus to broader social issues. Rosler aligns documentary photography with substantive social activism (of the kind provided in Vancouver by the Downtown Eastside Residents Association, the Downtown Eastside Women's Centre, and the Carnegie Centre, among many other groups based in the community), and takes an oppositional stand against the promotion and circulation of images in the art world, declaring that:

. . . the higher the status accorded to [photography] in museums and galleries, the greater will be the gap between that kind of documentary [the kind that twists arguments into generalizations about the condition of "man"] and another kind, a documentary incorporated into an explicit analysis of society and at least the beginning of a program for changing it.[16]

Tied to a program of revolutionary politics, Rosler's work straddles documentary and aesthetic strategies of representation. To avoid co-optation by the market, however, this work confronts the viewer with a pared down series of visual and textual quotations that at once confirms experience and creates an opening between representational systems in which activism can grow.[17]

Douglas' image is related to Rosler's, but places a greater stake in the potential of aesthetic strategies to engage spectators on both an unconscious and conscious level. He illuminated the street with the help of professionals using cinematic lighting, bringing into view something not seen in this way before. The block, in fact, does not look like this when viewed from across the street. The picture offers viewers more than conventional documentary photography allows for. The minute and myriad changes the artist made to the appearance of the block (using computer technology) can be linked to changes in a viewer's relationship to the space of the representation, and, potentially, to the space it represents. Unlike Rosler's work, Douglas' picture has no textual component to guide spectators and ensure that they read the image in a proscribed way. Douglas seems more interested in keeping the potential for multiple interpretations open. His work offers more leeway to spectators, more room to invent meanings, and employs perspective to enhance this effect. As a result, there is no necessary connection between the image and the people who live or have lived on this street. Spectators who seek a representation of Hastings Street that includes the human beings who live on it must conjure it on their own.

Thomas Struth, *United Nations Plaza New York/Murray Hill* (1978)
Courtesy Marian Goodman Gallery, New York

THE STREET IN PERSPECTIVE

A comparison with an urban scene taken by the photographer Thomas Struth puts into relief the formal characteristics and effects that distinguish Douglas' image. In 1975, Struth began a series of photographs of streets, shot from an identical centred perspective. *United Nations Plaza, New York/ Murray Hill* (1978), is a view down the street taken from the middle of the road. Two rows of gradually receding high-rises centre the view and draw eyes deeply into the space of the image. In Struth's composition, the street appears endless.

According to Renaissance treatises on perspective, three-dimensional illusionism is constructed by means of visual rays that emanate from two symmetrical visual cones, the bases of which meet at the picture plane. Perspective diagrams show how the rays of the first cone flow out from the spectator's eyes towards the picture plane, while the rays of the second cone, which begin at the surface of the picture, converge towards an illusionistic vanishing point. The perspectival regime in Struth's photograph adheres to this two-cone structure, which serves to shore up the viewer as a physical presence. The single vanishing point in the picture allows spectators an optimal position from which to view the image. From here viewers can measure the depth of the representational space and obtain an illusion of mastery and control. The rational and exaggerated representation of three-dimensional space in this photograph at once offers spectators a sense of their completeness as subjects and encourages them to believe in the picture as an objective representation of reality. Douglas' other panoramic view of the area, *The Downtown Eastside* (2002), is a sweeping overview taken from a rooftop. This image also establishes a fixed focal point and, to an even greater extent than Struth's, offers its spectators a commanding viewing position. For cultural theorist Michel de Certeau, "to be able to see

(far into the distance) is also to be able to predict, to run ahead of time by reading a space."[18] In this view, these images by Struth and Douglas can be seen as attempts to transform the uncertainties of life into readable space.

In contrast, *Every Building on 100 West Hastings* offers no single position for a spectator to occupy. There is no zero-point from which the image would spatially make sense *as a whole*. Instead, it has many viewpoints that compete for the observer's attention. To produce *100 West Hastings*, Douglas shot twenty-one photographs, which loosely correspond to the number of lots on the block, on the night of August 27 – 28, 2001 (as indicated on the six temporary "No Parking" signs in the image), and converted them into digital imagery with a high resolution scanner. The artist meticulously sutured these representations together on a computer using microscopic digital pixels to blend the joins between the individual shots and smooth out their perspectival disjunctures. He then printed the image in two parts using a light jet printer, seaming them together at the centre to form a sixteen-foot panoramic vista of the entire block.

Despite the striking realism of the final product, Douglas' urban landscape nonetheless maintains a composite appearance that is strangely precarious and unstable. The peculiar multi-perspectival reconstruction that unites the twenty-one separate photographs, and the strange, fluid way that they have been reshaped and positioned within illusionistic space, gives the block an uncanny, insubstantial appearance. Even though the well-known technology of Photoshop employs highly sophisticated means of masking the joins, the single image still communicates the integrity of the individual photographs. The result is an all-encompassing view that threatens to unravel into its separate parts.

The illusory sense of mastery one obtains from conventional photographs is denied in this image. Instead, the multiple perspective view has the disconcerting effect of appearing to converge *on* us more than

extend *from* us. Hence the instability of the scene undermines a viewer's ability to visually possess the image as a whole. As an observer fails to find a zero point or grounding around which the entire perspective view would cohere, an objective view becomes a highly subjective one. The fragmentation within the image itself then, in turn, communicates a loss of completeness or unity in the viewing subject. Instead of mastering the space of the image by precisely measuring its depth and breadth, a spectator is subjected to the image's particular mechanisms of display. The picture demands a different process of engagement and decipherment than conventional perspective views might, which in turn opens up new possibilities for the production of meaning.

Pedestrians walking on the 100 block West Hastings see the street from a vantage point which continually changes as they move. They cannot see the multiple viewpoints presented in this picture. Douglas' picture therefore offers something more than a captured image presented as a Duchampian ready-made or documentary photograph. Utilizing computer technology, it presents a painstakingly constructed composition similar to a topographical view executed in the eighteenth or nineteenth centuries, when drawn-on-the-spot accuracy was demanded of artists by a European public newly interested in phenomenological precision.[19] But the picture's fascinating realism, and the way that its shallow horizontal layout invites close inspection, paradoxically serves to point out the picture's lack: the missing people who normally roam this block at night.

The multiple perspectives of *100 West Hastings* demands that we as spectators adopt a staccato-like act of viewing that keeps our eyes moving as if we were engaged in a frantic search for something we have lost. Such activity brings with it an awareness of the eyes and body during the viewing process. The huge mass of highly detailed façades, each set within their own perspectival construct, is barely contained and supported from without by

the photograph's ten-inch white border. An irreconcilable tension remains between the separate images that together make up the singular image of this block. This tension helps to transform the spectator's gaze into a distracted glance, and perhaps too, into an anxiously searching look.

THE MISSING WOMEN

The photograph's deep emptiness provides an opening in which to contemplate the fate of Vancouver's missing women. Considering the mounting numbers of missing and murdered sex trade workers is one way to fill the picture's void. From this perspective, the image can be appropriated to suggest that the denial of the missing women can never be complete. Its emptiness can be mobilized to evoke a space haunted by the socially disprized and unloved.[20]

According to Silverman, there are two discrete stages involved in looking at an image, one unconscious, and the other conscious. The first stage consists of immediate perception and is unconscious. The second stage involves the slow process of looking again, and consciously reconsidering the value that the image has for us. In this conscious and repetitive looking Silverman locates the opportunity to transform the processes through which we displace onto another what we deny in ourselves. She sees this process as the crucial step in the establishment of an ethical relation to the socially unloved.

These two moments of perception are integral to the act of looking at *Every Building on 100 West Hastings*. The instantaneous view of this work starkly contrasts with the repetitious, contemplative viewing encouraged by its multi-perspectival structure. The artist worked through the night, from ten p.m. to six a.m., to take twenty-one shots, yet the work is composed to

look as if it were taken in one moment. This appearance coincides with instantaneity of vision: we see the picture as a whole, all at once. But the image's many perspective points slow our looking down. Purposeful, careful inspection is then encouraged by the picture's meticulous and seductive detail. Yet the composition blocks our vision with an uninterrupted row of façades, preventing us from seeing what lies behind the photograph's ostensible realism. In Douglas' picture perspectival recession into space is thwarted. At first, the fact that the view cannot be consummated by looking into the distance towards a single vanishing point may be frustrating. None of the multiple perspective views that make up the image allow viewers to see into the distance, or to see into the future. Nor does the image offer spectators the illusory sense of sureness that elevated viewpoints foster. The picture locates spectators at street level, and forces them to move along the façades, as if walking down the street, in order to obtain a series of fragmented, frontal views. The image therefore demands a subjective, repetitious, and time-based mode of apprehension and decipherment.

The two-staged process of perception that *100 West Hastings* encourages can be aligned with Silverman's ethical-political project of employing aesthetic representations in an identificatory and productive relationship to persons that we have been taught to despise.[21] Silverman observes that:

> For the most part, representational practice works through such mnemic "implants" to confirm dominant values. However, implicit in their exterior derivation is the possibility for each of us of having psychic access to what does not "belong" to us – of "remembering" other people's memories. And through these borrowed memories, we can accede psychically to pains, pleasures, and struggles which are far removed not only from our own, but from what normative representation validates, as well.[22]

To remember other people's memories is to identify with them and thereby reassert their social value. The use of a new category that Silverman describes as the "good enough," serves to break down the binary of ideality and abjection that fosters aggressivity toward others. Seeing alternative images as important means of bringing disparate communities together, Silverman contends that the notion of the "good enough" needs to be put into practice in relation to other bodies before we can learn to use it in relation to ourselves.

Since 1978, women from the Downtown Eastside in Vancouver have been going missing and at least fifteen have been murdered without inciting outrage in the broader community or the swift action of the police. A consequence of this widespread indifference, as Vancouver residents have recently learned, is that fragments of some of these dead women's bodies may have entered the food chain through a local rendering plant. West Coast Reduction Ltd., at 105 North Commercial Drive, processes animal remains to be used in several products, including animal feed and cosmetics. As the local press reported, parts of the missing women's bodies have been found on a pig farm in Port Coquitlam, B.C., and one of its owners, Robert Pickton, who has been charged in the murder of fifteen (as of early November, 2002) of the missing women, regularly sold pig entrails to this rendering plant. According to a report in the February 13, 2002 issue of *The Vancouver Sun*, Sheila Fagnan, a regional director of the Canadian Food Inspection Agency, made inquiries after learning that Pickton had met the women he is accused of killing on his trips to the rendering plant. She admitted that the only inspection done at the plant is a visual one, with no testing to determine the origin of the material received. Her comment that, "Any testing that would have been done would be around surveillance for chemical residues. I can't imagine any testing that would distinguish, um, you know – animal matter one from another,"[23] implies that there is no

Robert Pickton's pig farm, Port Coquitlam, B.C., 2002

Photos: Ian Lindsay, courtesy of The Vancouver Sun

way of knowing if bodies or fragments of the bodies of some of the missing women ended up there. The ironic horror is of a visceral return – of a corporeal linking through the food we consume and the makeup we use – with those who have been marginalized and despised.

In this context, a possible effect of looking at Douglas' panorama is to put the viewer's established notions of subjectivity at risk. Such a response entails a fundamental shift in spectatorship. Rather than assume a commanding gaze of the image, the viewer becomes conscious of the effects of its visual mechanisms. The picture's multi-perspectival construction and street-level angle of vision work as constraints that require a change to our accustomed way of viewing three-dimensional illusionism. Beyond bringing us into greater proximity to the 100 block, a viewer's corporeal adjustment to the dictates of the image may be a means of identifying more closely with the missing women, who themselves routinely experience objectification by those who repudiate them.

The link between the living and the dead that works to shape the meaning of *Every Building on 100 West Hastings*, particularly in Vancouver, lies within the invisible, repetitive "act that grasps it."[24] The reconnection of art and cultural politics might be made through our willingness to acknowledge we have failed these women, and to consciously transform the psychic and social representations that make such failures acceptable. To rephrase Montaigne cited at the outset of this essay, we still ought to have topographers – not to show us the faraway places that they have been, but to help us unmask the foreignness of the places in our midst.

For their thoughtful comments and support, I thank Erin Campbell, Robyn Laba, Ken Lum, Geraldine Pratt, Maureen Ryan, and Reid Shier.

1. *The Complete Essays of Montaigne*, trans. Donald M. Frame (Stanford: Stanford University Press, 1958), p. 152.

2. According to the Downtown Eastside Residents' Association (DERA), this neighbourhood includes the area bounded by Seymour Street, Smithe Street, and the Cambie Street Bridge to the West, Clark Drive to the East, Great Northern Way and Second Avenue to the South, and the waterfront to the North.

3. Chuck Davis and Shirley Mooney, *Vancouver: An Illustrated Chronology* (Burlington, Ontario: Windsor Publications Ltd., 1986).

4. Elizabeth Grosz, "Bodies/Cities," in Beatriz Colomina, ed., *Sexuality and Space* (New York: Verso, 1992), p. 250.

5. Kaja Silverman describes such identification as "the active gift of love." See *The Threshold of the Visible World* (New York and London: Routledge, 1996), p. 78.

6. Roger Chartier, *On the Edge of the Cliff: History, Language, and Practices*, trans. Lydia G. Cochrane (Baltimore and London: Johns Hopkins University Press, 1997), p. 91.

7. *Ibid.*

8. Michel de Certeau, *The Practice of Everyday Life*, trans. Steven Rendall (Berkeley: University of California Press, 1988), p. 169.

9. Roger Chartier, *The Cultural Uses of Print in Early Modern France*, trans. Lydia Cochrane (Princeton: Princeton University Press, 1978), p. 37.

10. Kim Bolan, "Missing Women List May Grow," *Vancouver Sun* (July 25, 2002), p. B1.

11. Silverman, p.2.

12. *Ibid.*

13. bell hooks, *Where We Stand: Class Matters* (New York: Routledge, 2000), p. 123.

14. See for examples: Andrew Hempstead, *Vancouver Handbook* (Emeryville, CA: Avalon Travel Publishing, 2000), p. 19; Paul Karr, *The Irreverent Guide to Vancouver* (New York: Frommer's Hungry Minds Inc., 2001), pp. 4-5; and Tim Jepson, *The Rough Guide to Vancouver* (London: Rough Guides Ltd., 2001), p. 49.

15. The Carnegie Action Project recently published a new study titled, *On Hastings Street – 30 Years of Retail History in Vancouver's Downtown Eastside, 1970-2000*, which claims that retail decline was caused by a change in shopping habits and the proliferation of malls and mega-stores rather than the drug trade.

16. Martha Rosler, "In, around, and afterthoughts (on documentary photography)," in Richard Bolton, ed., *The Contest of Meaning* (Cambridge, Mass.: MIT Press, 1989), p. 325.

17. Rosler, p. 323.

18. De Certeau, p. 36.

19. See for example, Charlotte Klonk, *Science and the Perception of Nature* (New Haven and London: Paul Mellon Centre for Studies in British Art and Yale University Press, 1996), p. 5.

20. In many of the accounts of the disappearances of the Vancouver women, there is a glaring gap between the time the women were last seen and the date that they were reported missing. Among the women recently added to the list, Wendy Louise Allen was last seen March 30, 1979 and was reported missing April 5, 2002. See Kim Bolan and Lindsay Kines, "Another Nine Women Feared Missing," *Vancouver Sun* (July 26, 2002), p. B2.

21. Silverman, p. 80.

22. Silverman, p. 4.

23. Kim Bolan and Lindsay Kines, "Food Inspector's Join Probe of Pig-Farm Connection," *Vancouver Sun* (February 13, 2002), p. A6.

24. Chartier, "Text, Prints, Readings," in Lynn Hunt, *The New Cultural History* (Berkeley: University of California Press, 1989), p. 161.

Downtown Vancouver, Burrard Inlet and the North Shore from 100 block West Pender, 1914

Courtesy of Vancouver Public Library Special Collections # 4704

CONTRIBUTORS

Denise Blake Oleksijczuk holds a PHD in art and cultural history from the University of British Columbia. Her work is included in the anthology, *Gendering Landscape Art*, edited by Steven Adams and Anna Gruetzner-Robins (2000). Supported by a postdoctoral fellowship from the Paul Mellon Centre, she is currently completing a book on the history of the first Panoramas in late eighteenth, and early nineteenth-century Britain. She is a former assistant curator of contemporary art at the Vancouver Art Gallery.

Neil Smith is a Distinguished Professor of Anthropology and Geography at the Graduate Center of the City University of New York. He is the director of both the Center for Place, Culture, and Politics and The Ford Foundation Project on Rethinking Area Studies. His books include *New Urban Frontier: Gentrification and the Revanchist City* (1996), *Uneven Development: Nature, Capital, and the Production of Space* (1984), and *American Century: Roosevelt's Geographer and the Prelude to Globalization* (2002). Along with editing (with P. Williams) *Gentrification of the City* (1986), his work on space, urbanism, and the geography of capital has appeared in numerous magazines, including *Social Text*, *Public Culture*, and *Society and Space*.

Jeff Derksen is currently a research fellow at the Center for Place, Culture, and Politics at the Graduate Center of the City University of New York and an assistant to Alfredo Jaar's "Project One: Culture in the Era of Globalization" at the University of Minnesota. His books of poetry include *Down Time* (1990), *Dwell* (1994), and the forthcoming *Transnational Muscle Cars* (2003). A former editor of *Writing* magazine, he also edited "Disgust and Overdetermination: a poetics issue" for *Open Letter* (1998). His writing on culture, urbanism, and globalization has appeared in various magazines, including *Hunch*, *XCP*, *Springerin*, and *Architecture Aktuall*.

Jeff Sommers wrote his PHD in human geography on poverty and the politics of space in the Downtown Eastside. He currently works as a research consultant with the Strathcona Social and Community Research Group and as a community worker with the Downtown Eastside Seniors Centre. His articles on the Downtown Eastside include "Men at the Margin: Masculinity and Space in Downtown Vancouver, 1950 – 1986" in *Urban Geography* (1999), and (with Nick Blomley) "Mapping Urban Space: Governmentality and Cartographic Struggles in Inner City Vancouver" in *Governable Places: Readings in Governmentality and Crime Control* (1999).

Nick Blomley is a Professor of Geography at Simon Fraser University. He has published widely on the politics of urban land, with particular reference to struggles in Vancouver's Downtown Eastside. His books include *Law, Space, and the Geographies of Power*, (1994), and *The Legal Geographies Reader* (2000), which he is co-editing. Forthcoming from Routledge is the provisionally titled *Unsettling the City*. His writing on inner cities has been published in numerous journals, including *Historical Geography*, *Law and Society Review*, *Urban Geography*, and *B.C. Studies*.

Reid Shier is a curator at Vancouver's Contemporary Art Gallery. He is a practising artist and critical writer. He was a founding co-editor of the magazine *Boo* (1994 – 1998), and was Director/Curator of the Or Gallery between 1996 and 2001. His articles and reviews have appeared in *Flash Art*, *Artext*, *C*, *Fuse*, *Canadian Art*, and *The National Post* as well as in numerous exhibition catalogues.

Stan Douglas is an artist whose work explores social histories played out through a complex cinematic and televisual language. His interest in the social implementation of western ideas of progress, particularly utopian philosophies, is located in their often divisive political and economic effects. His interrogation of the structural possibilities of film and video, in concert with intricately developed narratives, has resulted in a number of groundbreaking contemporary art works. These have been included in exhibitions around the globe, most recently in Documenta 11 and the 25th Bienal de São Paulo.

POSTER INSERT

A reproduction of
Stan Douglas, *Every Building on 100 West Hastings* (2001),
C-print (66 cm x 426.9 cm)

Courtesy of the artist and David Zwirner, New York